THE Art OF
Expressive Collage

THE **ART** OF
expressive
COLLAGE

Techniques FOR **Creating** WITH **Paper & Glue**

Crystal Neubauer

NORTH LIGHT BOOKS
Cincinnati, OH
www.createmixedmedia.com

Contents

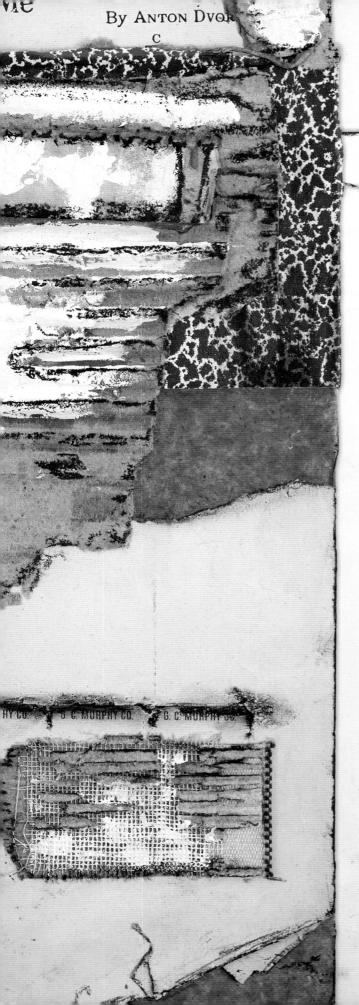

Introduction

I am sitting in my studio soaking in the sight of the supplies and materials that are essential to the work that I do. There are piles of scraps in front of me, arranged and waiting to be glued onto watercolor paper foundations, along with a stack of finished collage work neatly mounted and wrapped in cellophane wrappers in preparation for an upcoming show. Across the table are antique pitchers and salvaged jars full of paintbrushes, and a near-empty container of paste sits—lid ajar, abandoned after the recent completion of an overdue collaborative project. The wall to my right is outfitted with a salvaged office mail system, which now semi-neatly houses my favorite papers and scraps, while several large bins and a few boxes under the table contain an array of several years' worth of rummaging and foraging, and which, for all intents and purposes, most anyone would say looked like the household recyclables waiting to be put out on trash day.

Looking around, I can't help but think of the journey that brought me to this place: laptop in front of me typing out the words that will form a book that others will turn to for guidance in their own artistic adventures. Has it really been over a decade since the night I found myself searching the racks at the local bookstore for something to guide me through the stirring I was feeling around the art of collage? I remember with clarity coming home with a book by a popular mixed-media artist and setting off to work on the projects outlined in her book. And I also remember what great frustration I felt over the results. While what I produced did look like a beginner's version of the project I was following, it felt forced and did not resonate with my own artistic impulses. Something inside knew that this was not my voice.

We often come to the table with the expectation that there is a right and a wrong way to approach the canvas and fully expect that in every art medium there is the potential for a

Great art is the outward expression of an inner life in the artist.

—EDWARD HOPPER

good or bad outcome based on how skilled we are at following the rules. The idea of letting go of control is intimidating, especially when using precious found materials and investing in expensive art supplies. We see the work of others online and in magazines and think about the technical skill involved in producing that work of art and, if we have never had formal art training, immediately disqualify ourselves from being able to create something we feel emotionally connected to.

What does it even mean to work intuitively? When I sit down to work, bits and scraps and tattered remnants of old books and papers spread out before me, I am not conscious of anything outside of that space. There is no music on to distract, no TV droning on in the background, and yet I am listening intently. As I move the papers around, I am opening myself to hear, deep within, a voice, an affirmation, an internal nod. Something deep within my soul will stir, and I know I have heard from the still small voice. The creator's voice within, some may call it their muse or internal storyteller, some even say it is their inner child having permission to come out and play. No matter the term, this is the artist's intuition.

The intuitive artist is the artist who trusts what her eye tells her is good. She allows for the fact that she has a story to tell through art, but lets go of the notion that the story will be known before she starts working. It is not so much about learning a technique as it is learning to trust that you know what you know. It is letting go of a plan, letting go of expectations and creating in spite of your fear. If you have been formally trained in art, it may mean learning to trust your eye rather than the rules. If you have never so much as taken an art workshop, it may mean giving yourself permission to play with the tools and materials you once thought were only for professionals. Either way, to work intuitively allows for the

finished work to be more than what the artist is capable of producing on his artistic merits alone. It allows for the voice within to translate to the canvas without the need to have to spell out the message and make it obvious to the viewer.

There is truly a story of redemption in each work of art I produce. Each bit of trash that finds its way into my work, each slip of paper or spine from a book, represents a piece of one's life. There are highs and lows. There are things we remember fondly from our past and things we'd like to forget about altogether. When looked at individually, these scraps and bits do not hold much appeal to the average viewer, but when bound together with graphite, chalk and glue, each scrap is essential to the final composition and the viewer sees it as beautiful. Not one element could be removed without affecting all the others. In the same way, every experience of our lives is vital to the person we are today; every fragment of time is essential to our story. I have discovered this is the overarching theme of my work as I have honed my craft over the years. What will you discover your story to be?

There is a relationship that is developed between the artist and the artistic process when practiced intuitively. A common mistake is trying to tell the canvas the story instead of allowing it to be released through the process. In my teaching experience, I am privileged to see that "*aha* moment" in the faces of my students as they learn to let go of control. I see faces that are radiant, imaginations being stirred and identity beginning to make itself known. It is my desire to be able to convey this sense of freedom to you while raising your expectations to create exceptional works of art. To take you from the fear of messing it up to the excitement of letting it flow.

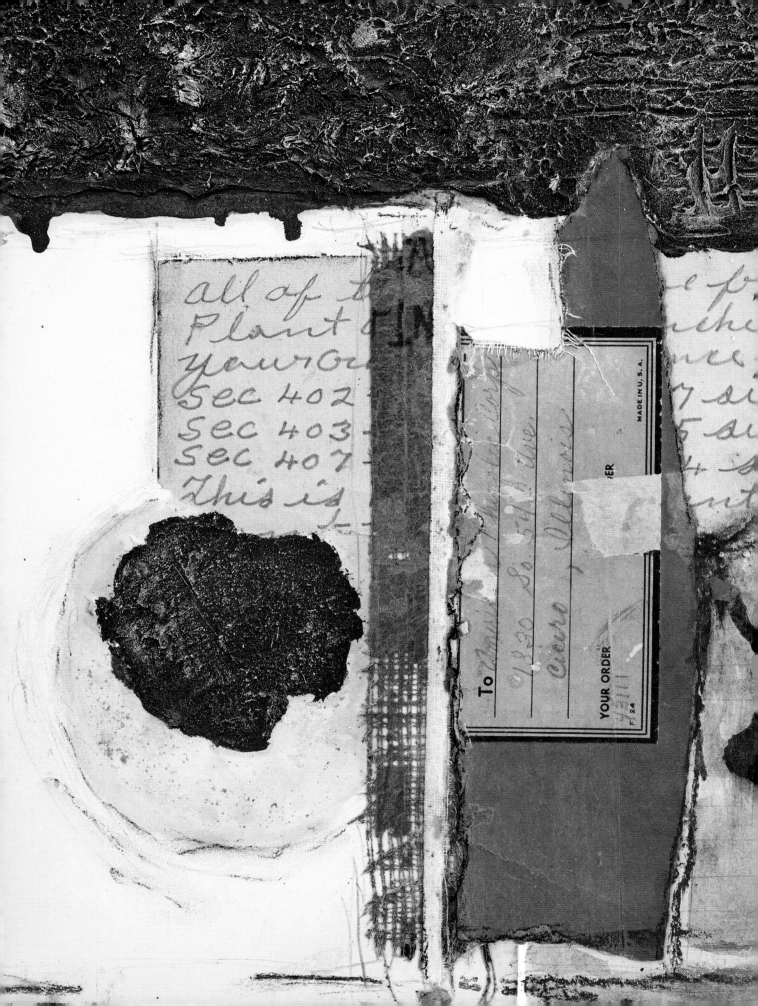

Collecting

Hunting and Gathering Materials and Supplies

I have gathered here an offering of other people's flowers, bringing to them of my own only a thread to bind them with.

— MICHEL DE MONTAIGNE

The process of becoming empowered to discover one's own artistic voice begins long before stepping foot in the studio or walking in the door of an art supply store. I began collecting the things I use in my collage work today before I had any notion of how I would be using them. I didn't know it at the time, but I was already practicing the art of intuition every time I brought home a pile of ephemera that I didn't know what to do with. Each time I picked up an antique book or a box of discarded photos at an estate sale, and when I called dibs on the stack of old love letters found hidden in the walls of my mother's childhood home, I knew in my heart these things were meant to be mine. They somehow told my story along with that of the previous owner. There was no conscious thought; I did not have words to explain. These things were a part of me, whether found in a stranger's home or my own.

The human brain is capable of processing billions of bits of information per second, but consciously we are aware of only a tiny fraction of it. As you get set to begin your hunting and gathering spree, I encourage you to make decisions quickly about what you collect, not based on any conscious thought process, but solely on your initial gut reaction. Logical reasoning sounds like "Don't pick that up; it is too dirty and worn, too weird, not the right color, too inconvenient and for goodness' sake somebody might see you!" Do not stop to question why something has caught your eye. If it has your attention there is a reason for it. Don't try to analyze it. This is where you can begin to put into practice learning to trust the voice within. By learning to tune in to your intuition you will respond to cues that sound more like this: "It takes my breath away. I don't know why, but I'm attracted to it. It is beautiful in its simplicity. There is just something about it. It moves me. I feel emotional when I look at it. I can't leave without it."

As the crow gathers all that glistens and is shiny, soon you will begin to see the common thread in the items you cherish. Your style is beginning to let itself be known, and others will start to recognize it, too. One of the best sources of collage material can be people who know you're an artist. I've had complete strangers send me items from a loved one's estate, my relatives frequently bring me things they've salvaged or found at a tag sale, and friends who were slow to understand what I do, now get excited to bring me things they think I can use. When this happens, use the same guidelines about listening to your internal response and be honest about it to the donors if what they are offering is not likely to find its way into your work.

Collecting at Home

One of the best things about using found material for your collage work is the cost. You can relax and experiment without worrying that you're wasting your money if you don't like what you've created. Like any other art medium, practice makes perfect in collage. Start with materials that you have little or no investment in, financially or emotionally, and free yourself to experiment with the techniques in this book with ease.

Remember as you search to let go of the analytical part of your thinking process and tap into the intuitive voice or feeling inside. If an item catches your attention and you feel a positive reaction to it, put it in your bag and move on. Don't stop to think about how you will use what you are collecting. If you feel a response to it, there is a reason for it, but now is not the time to figure it out. Trust what you feel and allow yourself the freedom to enjoy the process of collecting without the need to know exactly what you will do with everything.

Before I started working in collage, I collected vintage objects and ephemera so I had plenty of collage fodder on hand when I began to create. I rarely used anything that wasn't of an older vintage; I can't get enough of that natural aged patina, but lately I've been noticing the plethora of material to be found right under my nose. This is, after all, the age of sustainability, so why not use things that might otherwise be heading for the trash? Is it rainy and cold outside? The flea market is closed or too far away? No sitter for the kids? Get yourself a shoe box or grocery sack and get set to be inspired—your collecting begins without leaving the house!

Junk Drawer

Start with the junk drawer (you know you have one). A menagerie of lost electronic cords, batteries, old sticky notes, receipts and string. Personally, I can't resist the string! But what about the old receipts or expired sheets of stickers you were saving for free dishes at the grocery store? Any foreign currency left over from vacation that you didn't know what to do with?

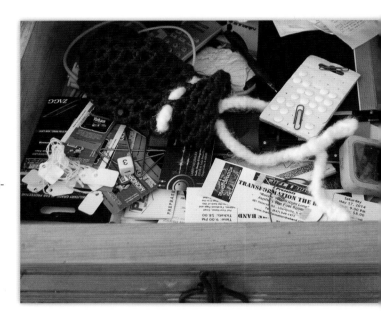

People often ask me where I find the "stuff" I use, and the answer is "Everywhere!" Luckily, the world has an abundance of stuff to offer an artist if she can just open her eyes to it.

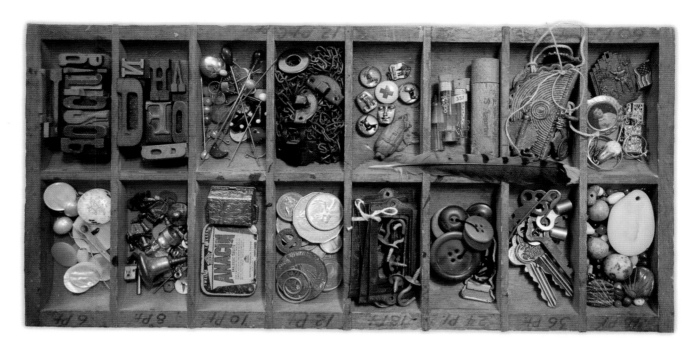

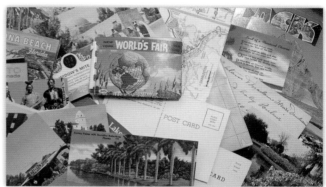

Collections

Like me, you probably have a stash of items you've been collecting for some time simply because you were attracted to them. Check out these collections and your other hobbies for potential material. Look for old sewing patterns or fabric, recipe books and recipe cards, out-of-date maps and atlases from your travels and even old paint sample cards from your last remodel project.

Pantry

Now have a look in the pantry. Packaging material is one of my favorite things to use in collage, and there is plenty of it to be found on the shelves of your pantry. Labels from cans and bottles, boxes from your pasta, tea bags (with the string!). How about the paper bags from your last shopping trip? Grab a few and I'll show you what to do with them when we talk about preparing your collage material.

Mail and the Recycle Bin

The mailbox is a great place to find material to work with. On a daily basis the mail carrier fills the mailbox with an array of colorful postcards, sales flyers and junk mail. My favorite items from the daily mail include envelopes of all types and sizes, printed material with large and graphic fonts, and sales catalogs (these I save for another purpose that I will show you, so go ahead and grab a few).

Don't forget about the recycle bin. Here you will find cardboard from old boxes. Shipping boxes, shoe boxes and boxes from the grocer, both the corrugated kind and the thin notched inserts that separate bottles or glassware, are great. Old newspapers, phone books and magazines also have great potential for collage. Don't be afraid to ask your neighbors to look through their recyclables, too!

Basement and Attic

Now head down to the basement or up to the attic, wherever you store all those boxes of family keepsakes. How many samples of your kids' spelling or math assignments do you really need to save? What about all of those old art projects and crayon drawings you kept; can you spare a few? Have a look around for old books that no longer have value, multiples of old photographs, old sheet music, manuals from the sewing machine or car you don't own anymore, and don't forget about my favorite—old packaging from items you use in the house: the mixer, the vacuum cleaner, the coffeemaker; perhaps you were saving them for just this purpose.

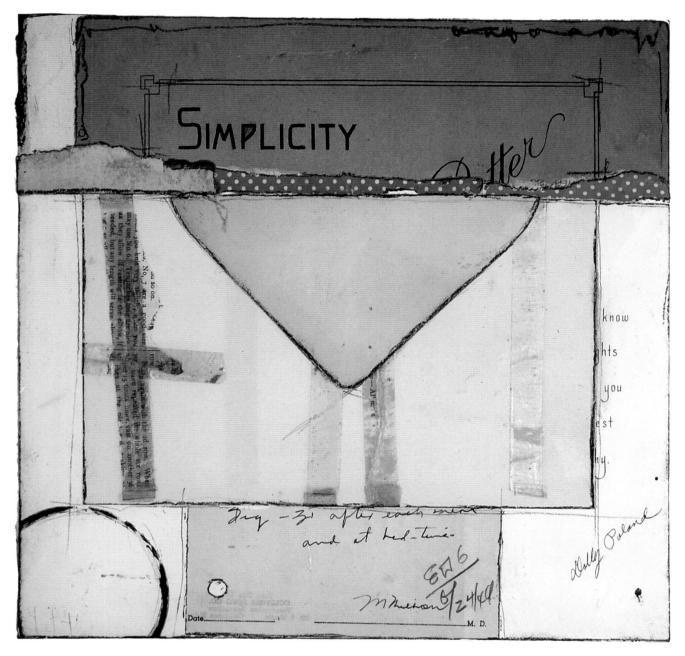

My foraging through the house and basement rewarded me with an old book of sheet music—the cover is seen at the top of this collage. I also found an old envelope and these delicious strips of yellow tape pulled from an old document with the text still attached. Other elements in this collage include a polka-dot design from the cover of an old Singer sewing machine manual, an old prescription and an old sympathy card.

Hunting Outside the Home

Okay, the house has been thoroughly ransacked and your stash of collage goodies is starting to grow. As a matter of fact, if you want to follow the projects in this book with nothing but what you've found around the house, you are good to go! But taking your hunt out of the house is a great way to jump-start your creativity and get that intuitive voice primed to start talking. Regardless of how big my stash is or how dry my creative well seems to sometimes run, when I come home from a search for new ephemera I am bursting with fresh ideas and can hardly wait to return to the studio.

Some of my favorite places to search are flea markets and estate sales; they are fantastic places to find an abundance of collage material. There are a number of sites online to point you in the right direction; if you'd like to check out the estate sales in your area, one of my favorites is estatesales.net. Many towns across the country host swap meets and flea markets on a monthly basis. The best of them are treasure troves of antiques and vintage items, which I love to use in my work. I am lucky to live in a town that hosts an excellent antique market every second weekend at the local fairgrounds.

Good to Know

Vendors expect to negotiate on most items. If the item you want to purchase is already inexpensive, you'll have a better shot at getting a deal if you purchase several items from the same booth.

I have a few rules that I try to hold myself to when I contemplate a purchase. One is about condition and the other is price. No matter how much an item has captured my attention, if it is in pristine condition or is over my budget, I tend to pass it up. There are simply too many items that are already falling apart and would be heading to the trash if I didn't rescue them to justify tearing something apart that is in excellent shape. The exception to this is when an item can be found in abundance and has absolutely no outstanding value; think old book-of-the-month edition books that can be had by the bagful at your local library or thrift shop. By the same token, I am cheap when it comes to purchasing something I know I am going to tear up. I won't pay more than a couple of dollars for an old book, and I cap my spending on any one lot of material at around twenty dollars. There are some exceptions to this rule as well, and it has to do with intuition, that voice that says I will never stop thinking about this thing if I don't take it home with me today. I rarely regret listening to that voice, but it helps to take cash and leave the credit cards at home.

While we're on the subject of spending habits, who says you have to pay for your material just because you aren't looking inside your home? Take a drive around your town and keep an eye out for houses with Dumpsters parked in front of them. Sometimes all you will find are lumber scraps

from a building project, but every now and then you will get lucky. My brother once hit the jackpot for me when he noticed a Dumpster in front of a house that had recently sold. Inside was what seemed to be the abandoned contents of one family's entire lives. There were scads of old books and family memorabilia, along with an entire paper bag filled with handwritten letters spanning from the late 1800s to the early 1980s. The items had been abandoned when the house had been put up for sale and the new owners didn't want them. Digging through the trash, now that's brotherly love! If Dumpster diving is not your thing, you can still find great stuff for free. Check out your local wallpaper store, paint shop or decorating center for things like old wallpaper books, paint sample and laminate cards, and more. Some businesses are more than happy for you to take these outdated samples off their hands.

Now let's head out together to see what else we can find.

Not all flea markets have the same focus, so it is important to search out one that insists that its dealers sell only antiques and vintage items. The best of them have a rule that items cannot be any newer than twenty years old. Take a wheeled cart or large bag with a shoulder strap to tote all your loot. You can expect to do a lot of walking, so comfortable shoes and weather-appropriate clothing are a must.

Carefully look at the seemingly hodgepodge array of items when a table catches your attention. Some items will simply speak to your design sensibilities but not be suitable for your artwork. Other things may, at first glance, not be a good fit as a whole, but what happens if you break it down? Think about using just the components of an item and suddenly you are hunting for buried treasure.

Estate Sales

Estate sales include the entire contents of a home after the owner has passed away and often are more likely to have inspiring materials to use than an ordinary tag sale. I don't bother lining up at the crack of dawn to be the first in the door for this type of sale as the items I am looking for are usually the stuff that other people pass right over. While the serious collectors are perusing the fine antiques on top of the table, I am usually scrounging around the items that have been relegated to the basement or underneath the tables. I find it impossible to pass up an old box of photos or handwritten letters; as sad as the circumstances are at this type of sale, these items are being offered after the family has already had the opportunity to save what they want. I think of what I do as a way of honoring the lives of people who have passed before me; their stories join mine.

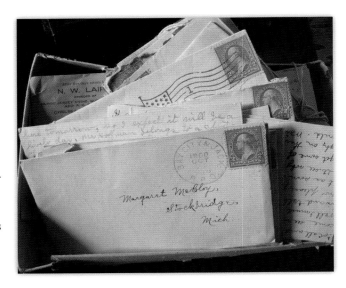

Good to Know

Book collectors and dealers are typically among the first people to arrive at an estate sale. By the time I get there it is usually safe to say that the books left on the shelf have no value beyond the purpose I want them for, but when in doubt, I research the titles and editions online.

Old letters are a great resource for collage and can be found in abundance at antique flea markets. The handwritten script can add to the story of the collage, but be mindful not to let any one element become the focus of the collage to the detriment of the rest of the composition. A snippet of the letter, a couple of words or a few incomplete sentences can add to the mystery and tease the viewer's senses more than if you attempt to use the entire letter.

And don't forget about the envelope! Open it flat, or use it as is. I like to tear the stamp off and turn it over to reveal the yellowed glue side. Always double-check the value before doing something like this, but you should find that most of these stamps are very common.

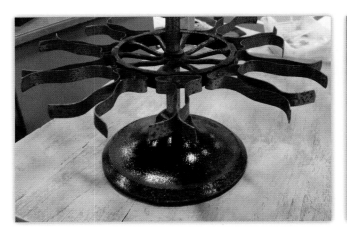

Old office equipment is another great way to bring style into your studio. Imagine this old rubber stamp carousel holding your paintbrushes instead. Find old magazine racks, wire desk baskets or an office mail system to organize your papers. Drawers from an old desk can be used on a shelf to hold odds and ends just as easily as a basket. When it comes to organizing, learn to look at things beyond the original intended use.

Sometimes I get so caught up in looking at the things in the storage containers and on the shelves that I don't actually see what they are sitting on. Step back and get the big picture—is this wire basket something you can use for storage? How about the yellow shelf? A flea market is a great place to get a good deal on furniture to outfit your studio.

Auctions

Like estate sales, auctions are another great place to find a variety of useful collage material. Oftentimes paper goods will be auctioned by the box lot, and you can get them all very inexpensively. Each item or box lot is sold to the highest bidder; therefore, you must be willing to spend the time to wait for the items you are interested in to come up on the auction block and bid on them competitively when they do. It is easy to get caught up in the competitive nature of the process and go over what you had planned to spend, so it is best to have an idea of the value of the items you want before the auction begins and stick to your budget. Remember, as appealing as something might be, there is an abundance of these items in the world. Be willing to walk away when the bid goes too high.

Auctions are either held on location, just as an estate sale would be, or at an "auction house"—usually a warehouse location. The doors will open an hour or two before the auction starts. Make a list of what you want and the highest amount you are willing to bid to help you avoid impulsive bidding. (Picture courtesy of tradingplaceamerica.com.)

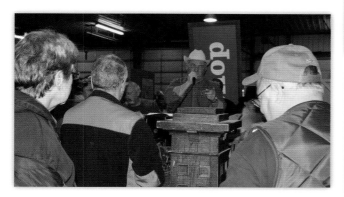

The auctioneer calls out the current bid and the amount he is looking for from the next bidder. The bidding can go very fast, but depending on the size of the auction, it can be an all-day event. Take a lunch and something to entertain you while you wait for the items you want to bid on. (Picture courtesy of tradingplaceamerica.com.)

Retail Stores

Antique shops, thrift shops and consignment stores are plentiful in most cities. Not only do I manage to find great items to decorate my house, but they can be a treasure trove of material to use for collage. Unlike estate sales and auctions, thrift shops and consignment stores typically have set pricing that is not negotiable, but the prices tend to be rock-bottom. On the other hand, an antique shop will negotiate on pricing. Remember that you are more likely to get a deal on smaller price points when you are buying multiple items.

A typical thrift shop will be organized into departments but have a jumble of items on each shelf. Rummage through the shelves and you might be surprised at what you find.

Resale shops are a great source for used books.

Among the newer titles are a few hidden gems. I look for books that have paper book covers in addition to canvas on the book boards and signs of wear and age. Try sanding the design with a piece of sandpaper for an interesting effect.

Gathering Supplies

An artist's work space can be just as important to the creative process as the supplies he chooses to work with. Whether you have an entire room for your studio or are sharing a space with the household office, the way you store your materials and supplies can either motivate and enhance your creativity or hinder it. Having moved several times over the past decade, I have had the opportunity to rethink and reorganize my studio space whenever I relocate it. Each time I do, I get a little closer to the most efficient use of the space available to me, while creating an inspiring environment I feel drawn to enter and stay in.

Working with multiple papers and found materials can make for quite a mess when I am in the midst of a creative frenzy. I will go with the creative flow and not stop until I feel my wheels are spinning unproductively and I'm producing more angst than anything. When I stop to take a breather, I find I have scraps and bits of collage paper in piles all over my table and trailing off to the floor. I have glue containers and other supplies strewn about along with scissors, paintbrushes and other tools. Before I can move on to the next phase of my art-making process, it is imperative that I stop and clean up. This is when the time I've spent organizing the room really pays off. Everything I use on a consistent basis is stored conveniently within reach of my table, and the papers are easily reorganized within a few minutes.

Just as having an organized space is important to the work flow, having the right supplies and tools on hand keeps you moving forward when inspiration hits. Nothing stops the creative flow faster than running out of glue in the middle of a project. It really pains me to have to jump in the car and drive to the art store and pay full price for what I need when I know I can get a better deal ordering online. I have learned this lesson enough times that I've started ordering multiples of the basics, especially when I have a show or important deadline coming up.

My stash of collage materials includes many found papers that I have prepared in advance for collage-making. A favorite source for these papers are text pages from old books that I have treated with splashes, drips and random marbling using ink, tea or paint. Typically when I work in the studio, I do so in complete silence, but when I am preparing these collage papers I turn on the music and let it guide my movements. So often when I am showing my work, these splashes and randomly made patterns have set the mood of the piece and are the first thing that draws a person in.

From organizing the space to purchasing the supplies and embellishing the papers you'll be working with, the time you spend preparing to work will pay off when you are all set to dig in. Think of it sort of like priming a wall before you can paint—it may not be the most exciting part of the job, but it makes the process a whole lot better in the end. First, let's have a look at the supplies and tools you'll need for the projects in this book, and then we'll look at storage and organization before moving on to prepping papers for future projects.

Adhesives

One of the questions I am most frequently asked is "Which adhesive should I use?" My advice, as with any of the supplies listed here, is to not get too caught up in finding the "right" adhesive when you first begin to practice the art of collage and especially do not let cost be a hindrance. I am a huge advocate of using what you have and if all you have on hand (or all you can afford at the moment) is an inexpensive bottle of white school glue, then by all means use that. I do encourage trying a variety of products on the market in order to get a hands-on understanding of what each one has to offer.

After many years of trial and error I have settled on a couple of products that serve me well in the studio. Yes! Paste by Gane is an acid-free, all-purpose adhesive with the consistency of paste. Each time I open a new container I am taken back to my youth when paste was among the required school supplies. Unlike the gel and decoupage mediums preferred by some, this product has a low water content, which is precisely why I love it. Many of the old papers I work with are delicate or may change color if dampened, and applying Yes! Paste straight from the jar can give me the adhesion I need without worry that the glue will saturate the paper.

As much as I love working with Yes! Paste, I find that it doesn't always give me the working time I need in order to reposition papers easily when used on its own. To solve this issue I combine it with Golden Acrylic Glazing Liquid in satin finish. The glazing liquid gives me a longer working time and a smoother application when applied with a paintbrush while still maintaining the adhesive properties of paste. I've noticed that the paste has changed in consistency over the years, and I don't always need to add as much glazing liquid as I once did, so my old formula of 4 parts paste to 1 part liquid is only necessary when I find a particularly dry batch of paste. Now I recommend that you start off with a smaller amount of glazing liquid and add more as you feel necessary, keeping in

mind that the paste should always be the bulk of the mix. Fill a baby food sized glass jar nearly to the top, pour the liquid over and around it, and stir thoroughly until the two products have smoothed to one creamy blend.

Paintbrushes

A variety of brushes are used for the projects in this book and are beneficial to have on hand in the studio. Economically priced multi-packs of natural bristle brushes are perfect for applying adhesive and can stand up to frequent use and abuse. I also utilize these brushes when using acrylic and oil paints. I can be very hard on my brushes and an inexpensive assortment gives me the freedom to simply toss them in the garbage when I'm done. Larger brushes are needed for encaustic wax painting and must also be made with natural bristles; synthetic is likely to melt from the high heat necessary to paint with this medium.

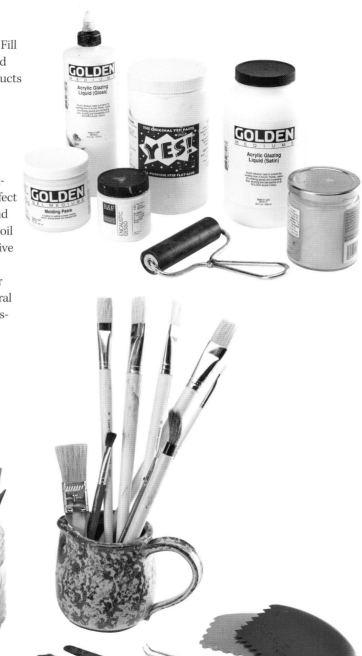

Watercolor Paper

The majority of my work is created on a foundation of 140-lb. (300gsm) watercolor paper. This enables me to work freely without fear of ruining a more expensive canvas or panel if I don't wind up liking the final composition. I keep multiple spiral pads of cold-pressed paper on hand and precut stacks of the sizes I most like to work with. Finished collage works intended for framing are affixed to another piece of watercolor paper at least 1" (3cm) larger on each side of the collage. For larger works on panel, I order large sheets of watercolor paper and cut to fit the panel before beginning the composition. The added benefit of working on watercolor paper as a substrate is that I don't have to cover every inch of it with collage paper. Open areas can be filled in with any number of mediums—paint, ink, charcoal or encaustic. The paper is sturdy and will hold its shape as I give it a workout.

Stretched Canvas and Cradled Panels

I often choose to display my work on a stretched canvas or cradled panel. The tactile quality of the materials I work with lends itself well to this type of display. I determine which is most appropriate according to the application of other mediums I plan to use. Stretched canvases are ideal when combining collage with paint or very thin single layers of encaustic wax, while cradled panels are the practical choice when the collage will cover most, or all, of the surface and for heavier multiple layers of encaustic wax with collage.

Glue Pads

Remember setting the junk mail catalogs aside when you searched the house for collage material? Well, this is where they come into play. Laying whatever you are gluing face-down on a clean page of the catalog enables you to apply the glue quickly without worry of getting any on your work surface. Each time you are ready to glue a new piece you can turn to a clean page in the catalog. When you've used all the pages, just toss it in the recycle bin!

Rice Bags

Seeing a pile of 25-lb. (11kg) bags of rice in my studio might lead one to believe I am preparing for a famine, but as unlikely as it may seem, they are one of the most useful tools in my studio. The large heavy bags serve to weigh down my work as it dries; the rice conforms to the shape of any dimensional or textural item in the composition without smooshing while holding everything snug and flat as it dries.

Cutting Tools

I don't do a lot of cutting when it comes to the material I use for collage, but I do have some favorite cutting tools and each one has a specific purpose. Scissors for trimming the collage to fit the foundation after it dries. Craft knives and razor blades are multifunctional, from trimming in tight spaces to carving and scraping encaustic wax. And of course my trusty paper cutter serves to cut the watercolor paper foundation down to size.

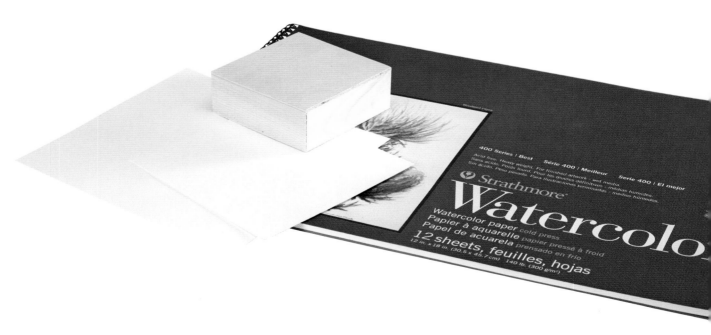

Graphite, Charcoal, Chalk, Pastels

I have a confession to make: I am obsessed with mark-making and mark-making tools, especially graphite. I have used graphite sticks, graphite pencils, powdered graphite and liquid graphite in my work and recently ordered a whole set of new colored graphite bars. I use graphite mainly for mark-making directly on my collages. Other writing supplies I frequently use in the studio are chalk, pastels and charcoal. The softer material of these products is ideal for writing on encaustic wax and painted surfaces.

India Inks

Black India inks are pigmented permanent inks traditionally made from carbon dating as far back as the 4th century BC. Colored India inks are derived from fine pigments in a water-based binder very similar to watercolor paints but much more water resistant. Both the black version and the colored can be diluted with water for a more transparent effect. I am quite fond of using these inks to add interest and compelling patterns to old papers and new.

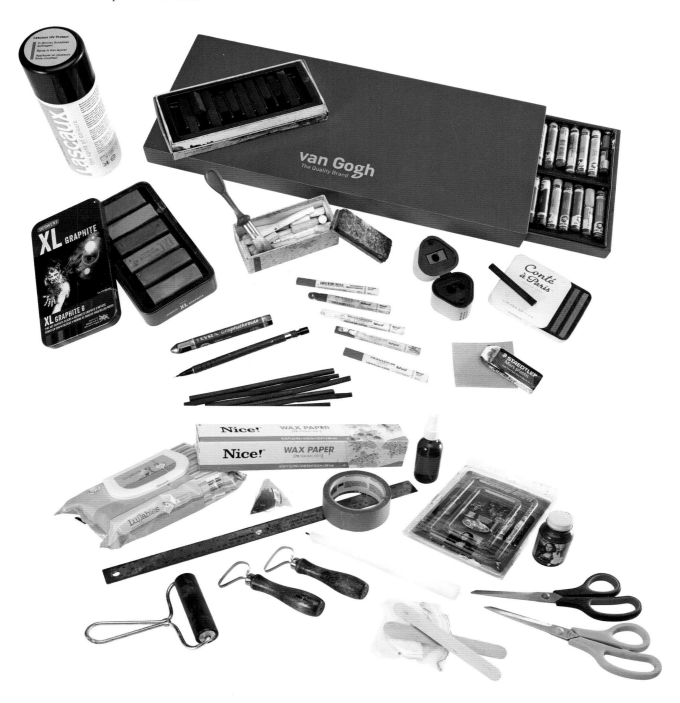

Paints

I have used a wide variety of paint in my work. A smear of color can serve to accent the tactile quality of the paper and subtly draw a viewer's attention. For the purpose of the projects in this book, brand and quality aren't important; use what you have on hand or find inexpensive versions to practice. Once you begin to develop your style and want to take your work to the next level, you can explore the differences between brands and grades.

At its very core, paint is simply pigment and binder. Acrylic, watercolor, oil, egg tempera and encaustic all carry the same basic pigments in different binders.

Acrylic

Acrylic paint is a polymer emulsion-based medium, with low or no odor, that dries quickly and can be cleaned with soap and water. Acrylic paints are the perfect choice when drying time matters. They can be worked in multiple layers without fear of unwanted blending, and the color will not fade or yellow over time. They can be thinned with glazing mediums or water and thickened with gel mediums and pastes. A multitude of tricks and techniques can be used with acrylic paint to get a seemingly unlimited number of finishes on a seemingly unlimited number of surfaces.

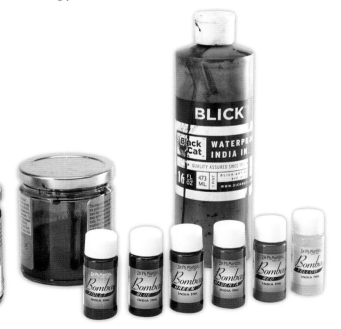

Oil Paint and Oil Paint Pigment Sticks

As the name implies, oil paint consists of pigments ground with various oils, typically linseed. Oil paint pigment sticks also have a percentage of wax binder to hold their shape. Oil paint has a much longer working time than any other paint and thus requires patience to allow for the time needed to dry. Oil paint does have an odor, so a well-ventilated working area is a must. Cleanup requires turpentine or mineral spirits, and special care is required in disposing of these materials. Unlike acrylic, oil paint is compatible with encaustic wax, which is how we will be using it in this book.

Encaustic Medium

Encaustic wax is an ancient medium consisting of a mix of beeswax and damar resin. It can be used as is for a clear finish or mixed with pigments when color is desired. Encaustic wax must be melted and applied while hot, requiring the use of special equipment to heat the wax. It dries as it cools and can be manipulated to create texture or smoothed to a fine finish. Many other mediums can easily be combined with encaustic; the translucent nature of the wax makes it especially appealing to the collage artist.

Basic Encaustic Tools

There is a misconception in the art world that certain mediums are not practical for the artist to try at home because of the large investment required. Encaustic wax is one of those mediums, and while it is true that some of the equipment can get very pricey, it isn't necessary for the beginner, or even the experienced artist, to spend a lot of money. Here are the tools we'll need for the projects in this book and suggestions for a realistic and inexpensive setup.

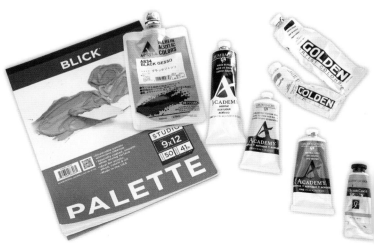

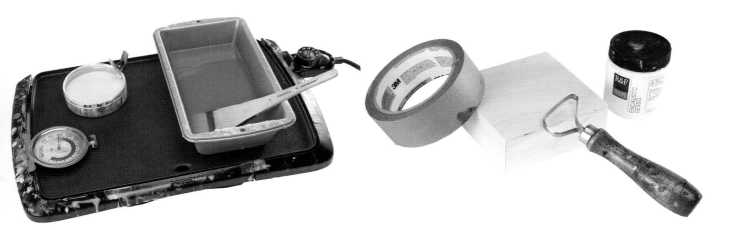

Electric Skillet or Griddle—Purchasing this piece of equipment through an encaustic supplier can cost hundreds of dollars and isn't necessary. It also is unnecessary to have both. An electric skillet is designed to hold grease and fry food. In the studio, it is useful to contain many pounds of melted encaustic wax. When not in use, simply unplug and replace the lid with the wax inside.

A griddle is a flat surface, generally used for cooking foods such as pancakes. One griddle with a loaf pan to contain melted wax is an ideal setup for a beginner. The surface can hold a metal loaf pan to contain melted wax, with enough room for smaller tins of pigmented colored wax.

My setup includes two of these flat griddles for multiple tins of colored wax, with a recent addition of a deep skillet to contain my clear medium. You can pick these items up at any department store with a kitchen department for very little money. Even better, take a look at your local thrift shop or search out garage sales in your area, where you can usually find them in great condition for just a few bucks.

Surface Thermometer— On my griddle I have an oven thermometer that I purchased at a hardware store for five dollars. It isn't completely accurate, but it serves to help me keep an eye on the temperature fluctuations and is much better than relying on the temperature control that comes on the appliance. Alternatively, there are excellent surface thermometers to be had at a range of prices at any good kitchen store or through an encaustic supplier.

Tins and Metal Loaf Pans—Recycled cans—the type that come with a pull-top such as tuna—are the most economical way to supply your studio with tins to melt your wax. Metal loaf pans and muffin tins are also perfect for melting wax and keeping the colors separate.

Ceramic Loop—This tool has a wood handle and looped blade on the end and is designed for use by the clay artist. This is handy for scraping back layers or smoothing the surface of the wax. Find one at any art supply store.

Heat Gun or Torch—These are used for fusing each layer of wax applied to the one beneath it to provide a stable bond and smooth surface. I have used both over the years and prefer the torch, but for the beginner the heat gun is a logical choice. It provides the heat needed without the concern of an open flame in the studio. A hair dryer or embossing tool will not be hot enough to do the job, so head to your local hardware store and find a basic model that has adjustable heat settings or check the local paper for a handyman's garage sale.

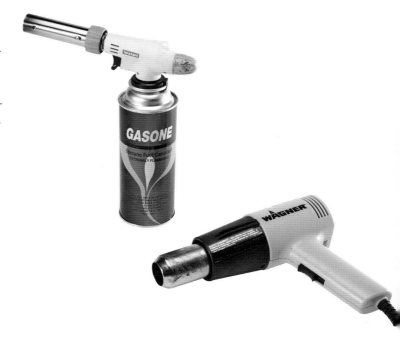

Storing Supplies

It is said that creativity is a spiritual act. For me, this notion is absolutely true and thus, the appearance of my surroundings is very tied to my ability to tap into the inner voice and allow the creativity to flow intuitively. When my work space is cluttered with a disorganized mess, my mind cannot rest on my work; it also becomes cluttered and flits about.

A good friend tells me she feels weepy every time she enters my studio, a reaction, she says, that comes from the spirit in recognition of the fragments of unspoken language of the collage materials I have on hand. I take this as a huge compliment as this type of emotional response is what drove me to become a collage artist in the first place. It speaks to the visual appeal of these materials even when they are sitting in storage waiting to be used. Don't mistake this to mean that there is never a mess in my studio. When I am working I don't interrupt my time to stop and clean every ten minutes, and the very nature of working in collage dictates that there are piles of scraps surrounding me, but when I do stop to catch my breath it doesn't take long to put everything back in order since I've taken the time to organize my work space.

Because there are so many different categories of supplies and materials, tools and whatnot to be had in a collage artist's studio, I would suggest looking at a wide range of storage, traditional and nontraditional, with multiple compartments, drawers and containers in order to find what you need quickly. When each item I use has a specific place to return to, I am more likely to put it away when not in use.

Durability is an important aspect to organization. When I am working on a project, painting for instance, I will bring the entire drawer of paints to the table with me. The frequency with which I schlep these bins and drawers and containers around the studio demands that I use sturdy containers capable of heavy use. Cleaning is also an important aspect to keep in mind, so opt for surfaces that are easy to clean up and won't be ruined if something spills. My tables are all secondhand pieces that I cover with roofing paper from the hardware store whenever I work.

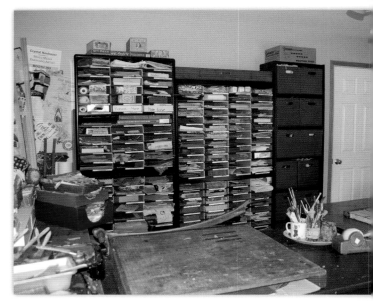

Work Zones

I'll admit it, having enough space in the studio to have specific zones for the different types of work to be done is a luxury, but even the smallest space can utilize some key elements from this approach to organizing. It can be helpful to measure each piece of furniture and your room, and draw a diagram before you begin to rearrange everything. Determine what type of art you will be doing in your studio most often and see how you can arrange the room to best allow you to have dedicated work space for each activity.

My room is divided down the center by two tables forming a T that extends from a third long and skinny table that sits along the far wall. For the most part, I sit at the table at the head of the T when I am collaging or painting. This is my main work zone. It is where I do all my collage work, as well as my writing and blogging. The table that forms the body of the T holds my large antique swing arm paper cutter—my cutting and finishing zone—which doubles as a work surface when I am gluing finished collage works to their support and when I am painting with encaustic. The table also holds several jars full of paintbrushes and palette knives that I use on a regular basis, and a small pitcher I use to hold clean water to rinse my brushes. The table against the back wall is a little taller, long and skinny, and holds my two electric encaustic griddles and my torch at one end—my encaustic zone—making it easy to heat up the wax when I want to use it. The other end of the table holds a storage unit with several drawers, along with a couple of wooden office trays and baskets that hold the papers I use most frequently in my work. Stationed at each wall are a variety of shelves and organizers creating zones for collage papers, tools and supplies, and a library of art books and magazines.

Repurposed Furniture

Giving old items new life is what I'm all about as a collage artist, so what better way to continue that theme than to repurpose furniture items for housing supplies in the studio? Take a look around your home; perhaps you have unused furniture stored in your basement or items your kids have outgrown taking up space in their bedrooms? Keep a watchful eye out at your local flea market or curbside on garbage day. My all-time favorite storage system is a set of four literature and mail sorters salvaged from an office when it closed. Stacked two by two, they take up the majority of one wall in my studio and are used to organize my favorite collage materials. I sort in visual categories, meaning I don't always have an explanation for what each slot holds, but my eye knows it is right. When I have these things out in the open, I am more likely to use them than when they are stashed in containers hidden away.

On the wall opposite the collage wall is a refinished antique cabinet from an old farmhouse kitchen that we used as a TV cabinet for several years. Now the shelves inside and several repurposed containers on top are the perfect place to store all my encaustic supplies. In addition to this, I have another cabinet rescued from a handyman's shop with nearly two dozen long skinny drawers that contain a variety of tools and all my paints and mark-making supplies. It's easy to grab one of the drawers and carry it to my table.

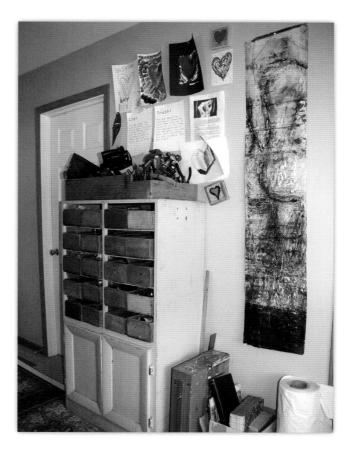

Traditional Storage Units

When thinking about a system to simplify your studio, the logical route might be traditional organizers specifically designed for this purpose. Think about the supplies and tools you have, sorting according to categories that make sense to your needs and how you plan to use them, and then look for appropriate containers, keeping in mind the aesthetics of the room and whether you want the items to be visible or hidden. I have a tall shelving unit that snugly holds twelve canvas cubes. These pop-up totes are available at large discount stores, container stores and even craft supply stores. They hold a lot and are perfect for hiding away messy supplies that used to take up a lot of shelf space. Each one is designated for a specific project or supplies: monoprinting, jewelry making, sewing, stencils, adhesives, solvents, etc. In addition to these pull-out bins, I keep a plastic stand-alone unit with two deep drawers under my work table with more collage material. Did I mention I have a lot of collage material? Yes, I also have several large rubber storage bins with lids to contain the overflow items that can easily travel with me when I teach a workshop.

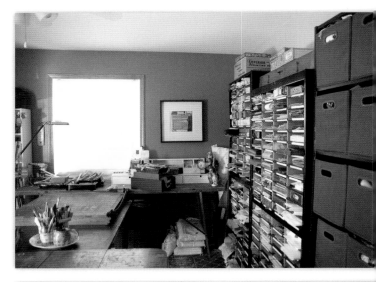

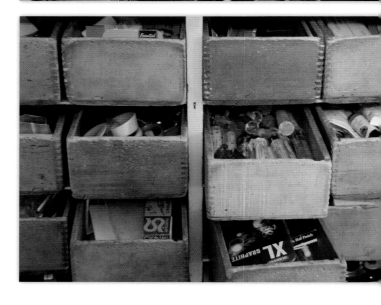

Off-Site Storage

When you have more need for space than actual space in the studio, think about what you can store off-site. By off-site I mean any location not directly inside your studio work space; for me, this includes a walk-in closet in the same room. You can also utilize available space elsewhere in the house or facility where your studio is located. Perhaps a designated shelf in the basement or garage? Just remember "out of sight, out of mind." If I have to go out of the studio looking for it, I most likely pass on using it, simply because it can break the creative flow to leave the room when I'm working. I won't, for example, store collage papers or paint off-site, but my unused canvases, cradled panels and watercolor paper are all stashed away in my studio closet, and items I need to ship finished art, like boxes, Bubble Wrap and packing tape, are put away in the basement.

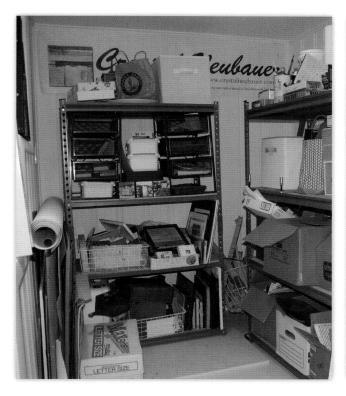

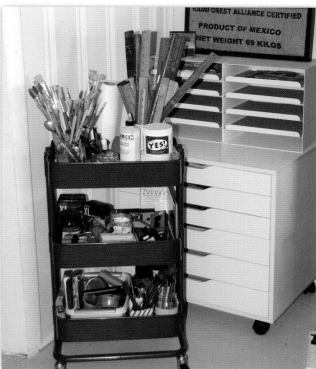

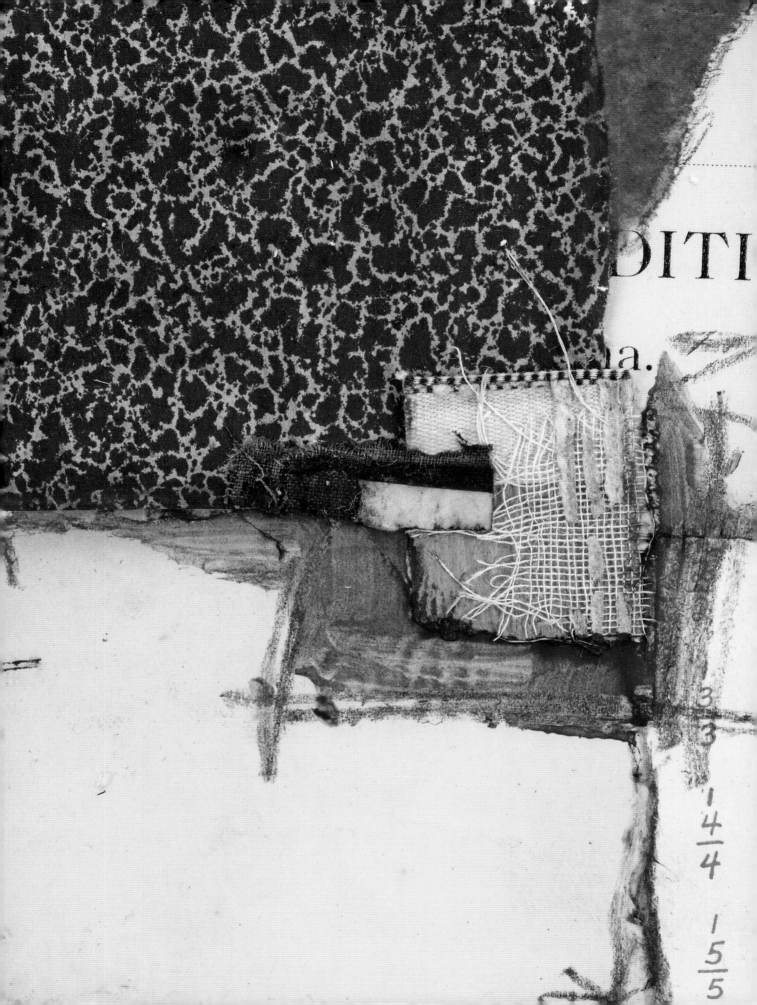

$\frac{2}{6}$

$\frac{2}{8}$

$\frac{3}{3}$
$\frac{}{9}$

$\frac{4}{3}$
$\frac{}{12}$

$\frac{3}{4}$
$\frac{}{12}$

$\frac{4}{4}$
$\frac{}{16}$

$\frac{3}{5}$
$\frac{}{15}$

$\frac{4}{5}$
$\frac{}{20}$

in

N,

2

Preparing

Getting Various Papers Ready to Collage

One common misconception about working intuitively is that there is no planning or prep work involved. Nothing could be further from the truth.

Some of the mark-making I am so fond of using in my work can be done in advance and saved for another day. Ink splashes, repetitive patterns, marbling and paper staining are some of my favorites. I work these papers in batches so I always have them on hand when I am ready to create my collages. These techniques are great to do on a lazy afternoon when I want to be creative without an end product in mind; they are also very therapeutic. This is one time I will put music on in the studio. The tunes depend on the mood I'm in or trying to achieve. Sometimes it is fast and fun, other times it is worshipful and other days it is more of a somber, reflective tone.

You will want to approach these exercises as free of expectations as possible. Your inner critic stands at the ready to let you know when you have failed. With the intuitive process, there is no right or wrong outcome, only results that you are more or less attracted to. If the result of a particular batch of mark-making is less desirable to you, set it aside for another day. I've had papers I prepared and was tempted to throw away suddenly become the key element that livens up an otherwise lackluster collage. The only imperative here is to allow yourself to enjoy the flow and unpredictable nature of the activity, as it was in your childhood when you were able to engage in art-making for the pure pleasure of it.

Methods With Ink

India ink is one of those materials I consider to be essential in my studio. Over the years as a collage artist, I have grown bolder about making my own marks within the composition. Ink-splashing is one of those methods that truly impresses the viewer with the feeling of an unspoken language. One simple drip or splash of ink can stop a person in her tracks and draw her in for a second look. With the subjectivity of the famous Rorschach test, these splashes of ink can evoke an emotional response from the viewer as she applies personal experience to the abstract shapes. Not surprisingly, applying the ink with the splash-and-drip method can be a release of whatever the artist is feeling as well. There is an energy that is transferred through spontaneous application.

While I tend to gravitate toward an earthier color palette, with black ink being favored, a wide array of ink colors is available to choose from. One of the more delicate processes that utilizes multiple colors at a time is paper marbling. The artist must maintain a soft yet controlled touch as she applies the ink to the water's surface and then be willing to let go of the results to some degree.

When playing with these methods, choose an area to work in that won't matter if ink splashes on the floor (outdoors, garage, basement, etc.). When covering your work surface, allow for plenty of room to lay out wet papers to dry as you work.

What You Need

bamboo brush, soft bristle

disposable dish, small

India ink, black

India ink, pigmented, 2–3 colors

paintbrushes, several small (one for each color)

palette with multiple wells

papers: endpapers, old text pages, blueprints or paper of your choice

small plastic shoe box or dish tub

water

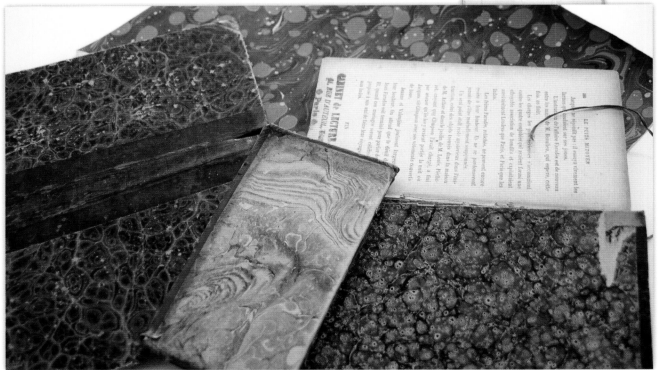

I collect and use antique marbled endpapers from old books in my work. They are also a great source of inspiration for color combinations and patterns when creating my own marbled papers.

Splashing

This exercise can be done on virtually any type of paper, new or used, as well as fabrics, book covers, cardboard or any other surface you want to try.

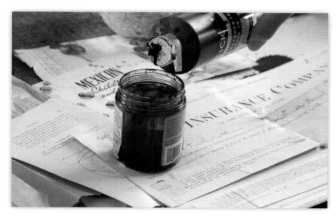

1 Lay out several papers at a time. Choose a variety of sizes and types of pages. I like to use the blank endpages from old books, canvas covers from old books, old sheet music and text pages.

Pour a small amount of black ink into a dish or jar.

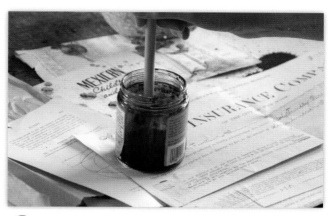

2 Dip the bamboo brush into the ink.

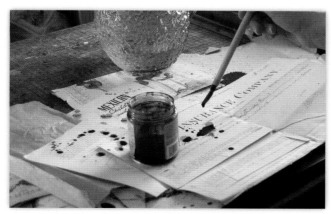

3 Hold the loaded brush over your paper and allow the ink to drip. (The closer to the paper you hold the brush, the tighter the drip mark. Hold the brush farther over the page and the drip will create a splash effect.)

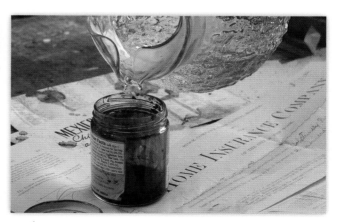

4 You can dilute the ink with water depending on the opacity you desire. I usually splash several pages with undiluted ink and then gradually add water to my dish, splashing a few pages each time, or splashing different strengths onto the same page for a mottled effect.

Marbling

Paper marbling is an art form in itself. Many antique books have beautiful marbled endpapers that are excellent accents to use in a collage. This short exercise is only meant to give a small overview of the technique.

Choose a variety of papers and pages to experiment with. I have found some papers take marbling really well and hold the pattern, and some simply run all over the place. One of my favorite papers to use is old blueprints.

Good to Know

After the ink has been absorbed by a sheet of paper, the surface of the water is free to accept more. You can repeat this process multiple times with one batch of water. If you notice the ink stops spreading on the surface as quickly, stop and get clean water.

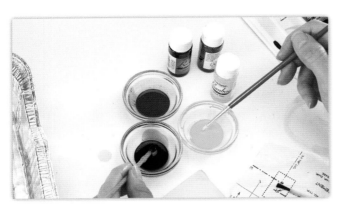

1 Pour a small amount of each color of ink into a different well in your palette.

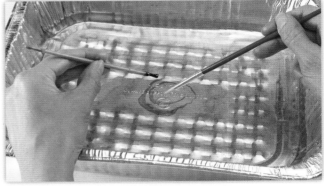

2 Starting with two small paintbrushes, dip each one into a different color of ink. Lightly touch one of the brushes to the surface of the water, creating a small circle of ink. Touch the second brush to the surface of the water inside the first circle of ink.

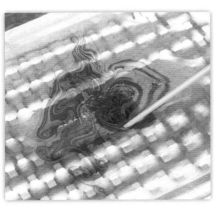

3 Continue to alternate, loading more ink onto each brush as necessary. This will create an effect similar to the rings of a tree.

Using the handle of one of the brushes, lightly swish through the water to move the ink across the surface in an interesting pattern.

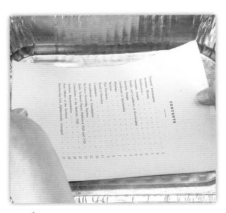

4 Now lay a sheet of paper on top of the surface.

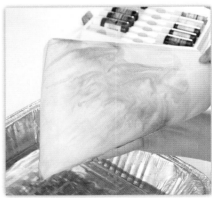

5 Lift the paper out of the water. The pattern of the ink should have transferred to the page. Set aside to dry.

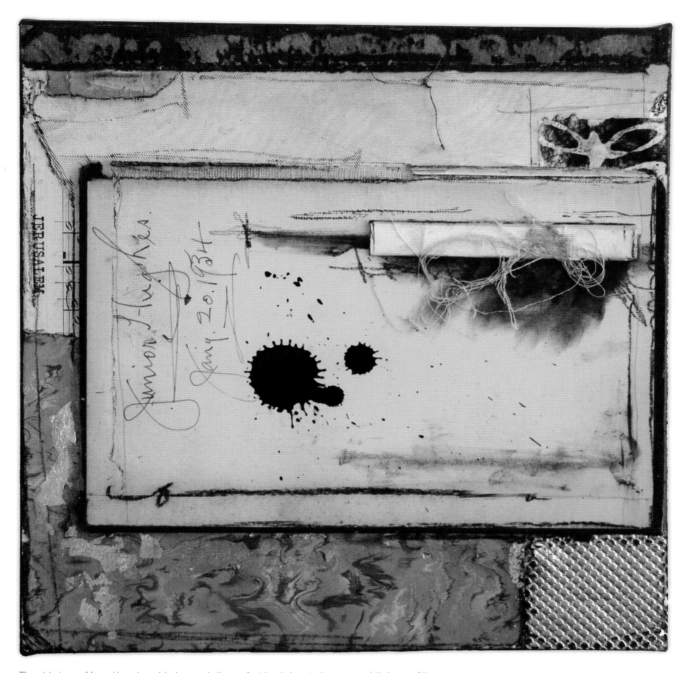

The old piece of found hand-marbled paper is the perfect backdrop to the more subtle hues of the old book cover with splashed ink for this collage titled *The Remnant*. The textural elements that accent it are the cloth from the spine along the top, a textured end page from a 1920's yearbook, gold vinyl from an old coin purse, and the mesh from inside the spine of a book with strings attached, all serving to lead the eye around the canvas.

Methods for Staining

When it comes to patina, nothing will do but the real thing for me. I prefer the look of natural aged paper over that created by some of the faux finishes available on the market today. But there are certain effects that I can't seem to get enough of, so I mimic them with food, beverage and fire.

Circle patterns add unexpected drama to the composition, especially those that look like they've been put there by chance or happenstance. I am most intrigued when it looks like something has spilled or has been left sitting on a book. There is a mystery to be solved; an accidental mark has been made by another. Who set that cup down there? Were they bothered by the fact that they spilled, or were they so caught up in their studies they didn't notice? By choosing to use a piece of paper in your collage that has a random pattern stained into it, you introduce a dialogue to the viewer. It can be subtle or alarming depending on your selection of other materials and how they are placed on the canvas.

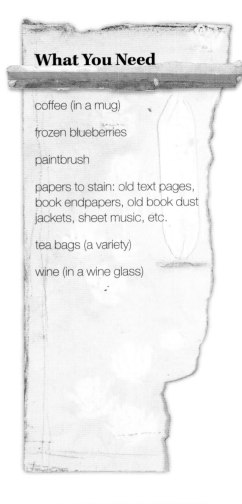

What You Need

coffee (in a mug)

frozen blueberries

paintbrush

papers to stain: old text pages, book endpapers, old book dust jackets, sheet music, etc.

tea bags (a variety)

wine (in a wine glass)

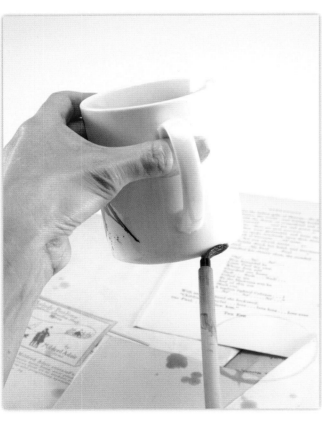

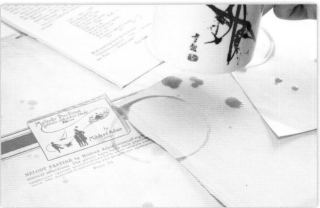

Coffee

Wet the bottom of the mug with black coffee or tea and set the mug on top of the paper to be stained.

The longer you leave the mug, the darker the ring. Drip and splash some areas with a paintbrush dipped in coffee. Allow the paper to dry.

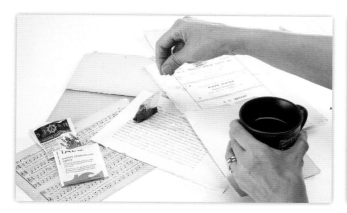
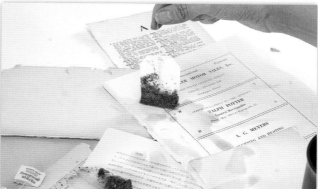

Tea Bags

Wet tea bags and set them on top of the paper to dry. Experiment with different tea flavors for a variety of color.

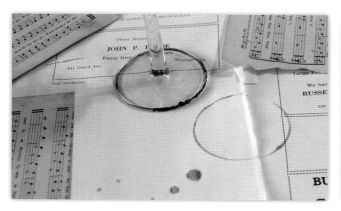
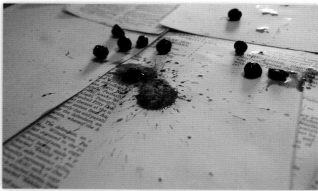

Wine

Wet the bottom of the glass with wine and set it on top of the paper to be stained. Leave it long enough for the wine to penetrate the page and remove. Drip and splash wine on some of the pages with a paintbrush. Allow the paper to dry.

Blueberries

Thaw several frozen blueberries. Place them on the paper and press to stain. Remove the berries, wiping away any pulp. Allow the paper to dry.

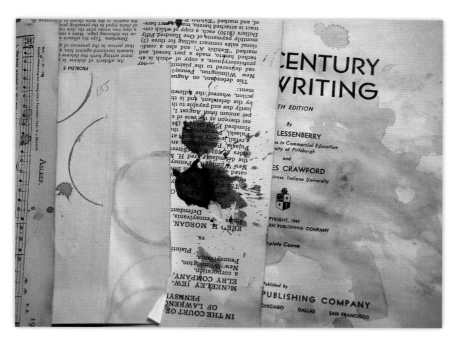

Left to right: wine, coffee, blueberries, tea-stained papers

Repetitive Patterns and Embellishing

Repetitive patterns, intuitive marks and just plain scribbling in a work of art have the power to engage the viewer and express emotions that are far larger than the arbitrary lines that they are. Flat on the picture plane, the repeat nature of some marks is designed to elicit an impression of texture that can tease the senses with a tactile appeal. It is, of course, an illusion, but one that evokes a near-primal response.

Marks made on paper reveal the maker's hand. This, too, plays a role in the larger story that will unfold as the collage is pieced together. Never you mind at this point what story that may be or what meaning each mark may hold. The intent here is to build an inventory of material to be used at a later time to allow for an unhindered flow of intuitive collage-making.

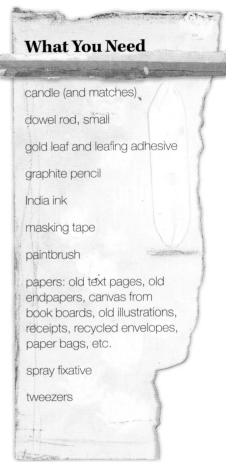

What You Need

candle (and matches)

dowel rod, small

gold leaf and leafing adhesive

graphite pencil

India ink

masking tape

paintbrush

papers: old text pages, old endpapers, canvas from book boards, old illustrations, receipts, recycled envelopes, paper bags, etc.

spray fixative

tweezers

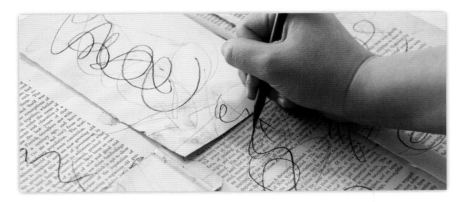

Scribble

Lay out a grid of 4 to 12 sheets of paper on your work surface. Allow yourself to completely relax, take the pencil in hand and begin to swirl it about the paper, like a child who is scribbling. Let your eye determine where the pencil marks should go. Let go of a desire to make it be something and just feel the sensation of the swirling. This is a great exercise to do with music. Seal with spray fixative.

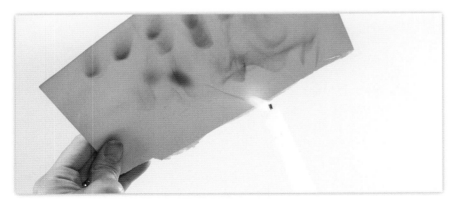

Smoke

Light a taper candle and hold it close to the page to allow smoke and burn patterns. Do not hold the candle too close to the paper or keep it in any one place too long. (It is a good idea to keep a container of water on hand to dunk the paper into in case it accidentally catches fire.) Seal with spray fixative.

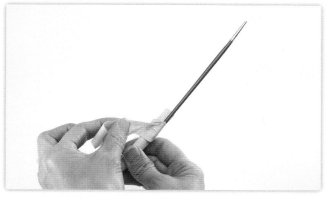

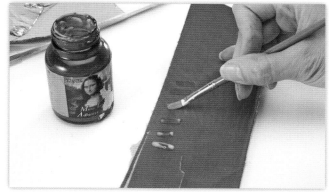

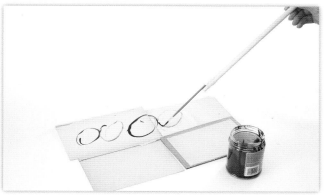

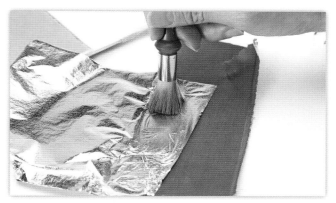

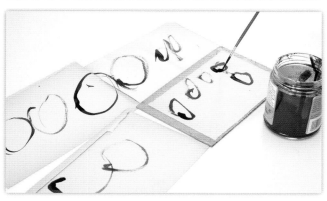

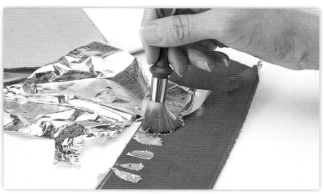

Express

This is a foundational mark-making exercise designed to connect the emotional self to the physical mark while letting go of the need to control. Tape a paintbrush to a small dowel rod with masking tape. Lay a series of old or new papers on the floor, taking measures to protect the surface below it, and load the brush with ink. Draw a series of marks: OOOOO, ||||||, XXXXX or dots. Allow your entire arm to move from the shoulder to control the brush. Notice how difficult it is to create a perfect mark. Experiment with a range of sizes in your marks, or try to make them as consistent as possible. Save these papers for future collage-making.

Glimmer

Using a paintbrush, make several repetitive marks on a page with the leafing adhesive. Pick up a sheet of gold leaf with tweezers and lay it down on the adhesive. Pounce the leaf with the top of a stiff brush to adhere the leaf and remove any excess by sweeping it away with the side of the brush.

Deconstructing and Recycling

One of the biggest challenges I see my students deal with as they begin the art of working intuitively is learning to see an item for its potential. A visual paralysis sets in that prevents one from seeing an object beyond its original form. A struggle ensues as the item held some sort of appeal when it was collected and is now deemed to be too precious to tear up. This is a common mistake when approaching mixed-media collage. Most of the time it has to do with a fear of ruining something special. But more often than not, these items will carry a greater impact within the composition when just a portion is used. One corner of an old handwritten letter can grab a viewer's attention and draw her in for a closer look. One scrap from the spine of the book will appeal to the senses, lend a suggestion of time or symbolize a greater strength. There is the hint of a story rather than having it smack the viewer in the face with the obvious.

A good composition should be viewed as a whole; no single element will command attention to the detriment of the rest. To achieve this result it is important to let go of any notion that the item cannot be replaced. If there is any doubt in your mind that the thing you are about to take apart is valuable, you will not relax and get into the flow, so do your research if you aren't sure. I once purchased a very worn piece of sheet music with an interesting cover for fifty cents at an estate sale, but when I got home something told me to double-check before I used it in my work. Sure enough, in spite of the deteriorating condition, it turned out to be quite collectable and I sold it on eBay for over six hundred dollars.

Once you have determined that you won't be able to put your children through college with your found treasures, you still need to let go of any notion that what you have in your hand is something of historical value. There are plenty of antique books in the world that have no collectable value and will only become landfill. Antique and vintage photos, for the most part, are common and in abundant supply. The key is to begin to look at what you are doing as conservation. Upcycling is a popular concept. You are not destroying, you are preserving. If an old book or photo is worth only a couple of dollars to collectors, you are adding to its value by using it as art, not the opposite. Go ahead and start to look at how things are made and how the elements may be used in a unique or interesting way. Try to avoid the obvious and overdone. Here I will share with you my favorite items to use in my work and how I deconstruct them into usable components for collage.

Books

To a collage artist, a book is not a book; it is a cornucopia of useful materials. Indeed it is one of my staple sources and I am always on the hunt for more. I often see old text pages being incorporated into the work of mixed-media and collage artists, but the elements that appeal to me more are the dust jacket, the cloth from the cover and the book board once it has been stripped. The spine of the book holds special symbolic appeal to me, representing inner strength, and has multiple tactile components to be gleaned for use in your work. Here I have stepped out the process of deconstructing an old book.

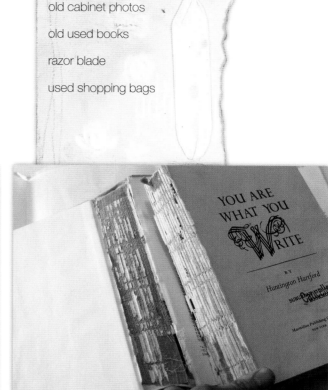

What You Need

old cabinet photos

old used books

razor blade

used shopping bags

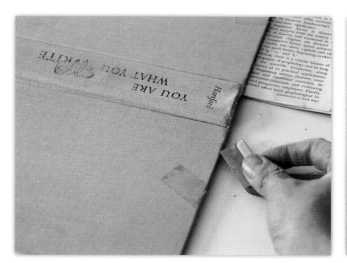

1 Remove the dust jacket and consider both sides for appealing material.

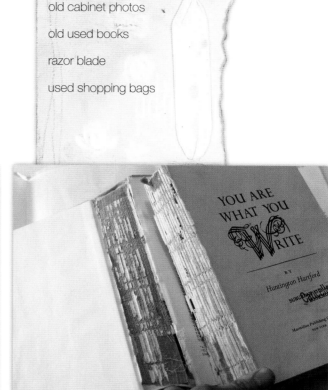

2 Pull the cover along with the endpapers away from the book, separating them from the spine as well.

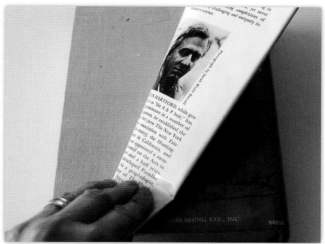

3 Run a razor blade along the edges of the cloth to make it easier to pull it off the board.

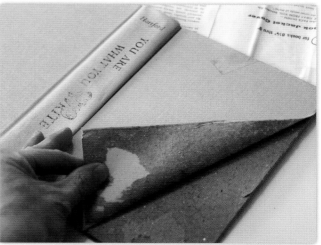

4 Remove the exterior cloth from the book boards by pulling firmly, starting at one corner.

5 Remove the endpapers—allow some of the paper from the book board to come up with them. Endpapers may be adhered to a fine mesh. Pull this away with the paper.

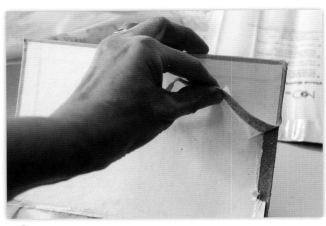

6 Remove the interior strips of cloth from the book boards.

7 Pull away the cloth and mesh from the glue strip on the spine. Some books may have a strip of glue and paper on the spine; remove this.

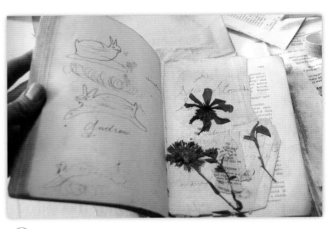

8 Flip through the pages for anything the previous owner left behind.

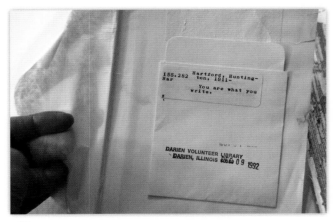

9 Consider saving unusual aspects such as a library card.

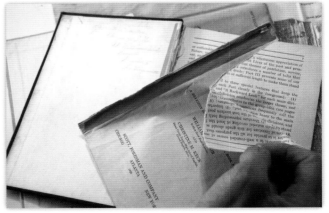

10 Look for pages that have old discolored tape.

11 Tear away the tape, leaving some of the page attached. One book can yield a bountiful collage harvest.

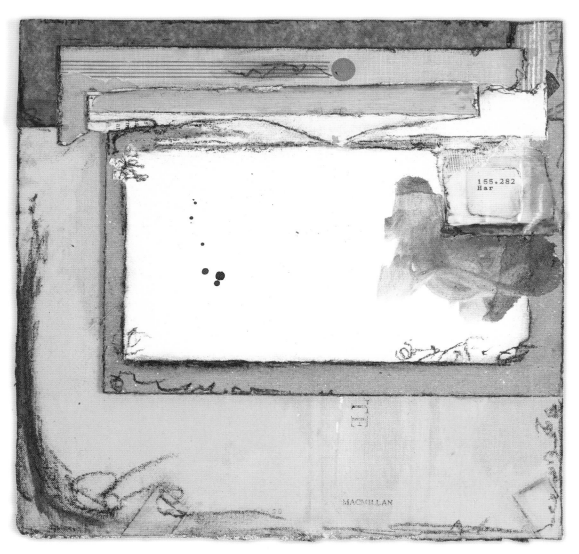

Inspiration hit me for a new collage using the components salvaged from deconstructing this book.
I've also included one side of the frame from an antique photo folder in this composition.

Cabinet Cards

Cabinet photos are another common element I see used in mixed-media collage and one that I found essential to my own work when I first began. But now I am drawn to the paper layers of the card more than I am to the photo itself. I first began using the paper layers like this when I purchased a box lot at an auction that contained many damaged and delaminating old photos.

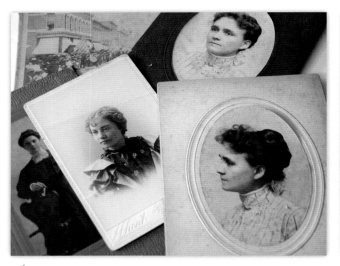

1 Find old cabinet photos in worn and dilapidated condition.

2 Pull the layers from the back of the photo.

Photo Folders

Vintage photo folders do not have the same layered construction as cabinet photos, but they hold many desirable elements. When the photo is pulled away from the backing, it frequently leaves interesting patterns from the glue. The frame portion of the folder is often embossed or foil stamped, and the colors of the folders are typically those that I gravitate to in my work: grays, beiges, tans and browns.

1 Look for vintage photos mounted in decorative card stock folders.

2 Remove the photo by pulling away from the folder gently. Evidence of the glue is desirable. Tear away sections of the folder's frame.

Grocery and Shopping Bags

Brown paper from grocery sacks is a great resource for collage. Use it for an expanse or pop of brown color in your work, splash it with ink, or use it in the repetitive mark-making exercises with graphite or charcoal. Pull the handles off and use them as a band of color.

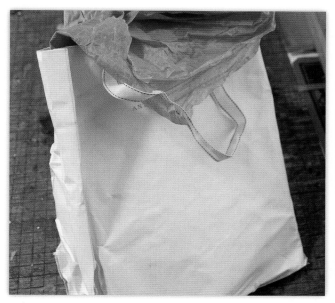

1 Many popular retail stores package their goods in lovely tissue and send them out the door in a beautiful bag. I got caught in the rain with this one and couldn't resist bringing it to the studio when I got home. I find the wrinkled texture of the paper very appealing!

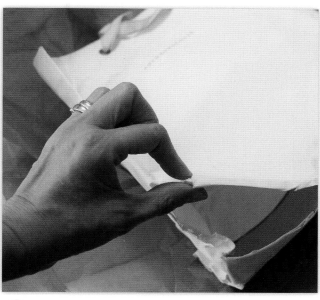

2 The corner was already torn, making a perfect starting point for deconstructing my bag. I chose to open the bag lengthwise in order to give myself a long strip of the worn white paper. Alternatively, I might cut or rip it into sections.

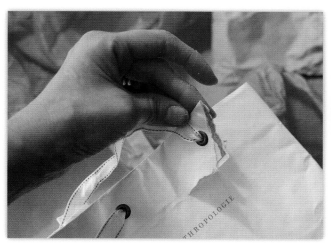

3 Using the chipboard insert as a guide, I gently tear away the top of the bag, allowing for uneven edges and interesting layering. I really like the look of the grommets in this bag. I remove the cloth handle and save it as well.

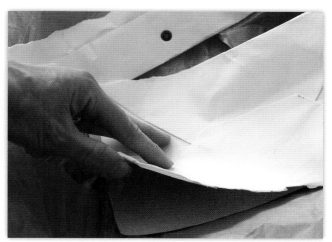

4 The bottom of the bag reminds me of an envelope. I can already envision how I might use it in a collage. I pull out the chipboard stabilizer and save it as well. One bag can yield multiple components to use in your work!

For additional content go to: www.CreateMixedMedia.com/TheArtOfExpressiveCollage.

Tea Bags and Coffee Filters

I am a coffee and tea drinker, so these items are in abundant supply in our house. I prefer the look of them after they have been used and have saved more than enough to keep me in collage material for some time to come. Open the bag and remove the tea leaves; you'll find that different brands yield different visual results. Save the bag, the string and the tag in your stash of materials. When I have an element I want to use in my collage work that I feel isn't as unified with the rest of the materials as I'd like it to be, a shiny postcard for example, I can overlay it with a tea bag to knock it back a bit.

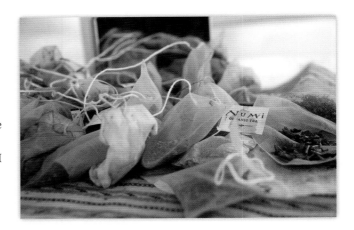

Corrugated Cardboard

Another staple in my studio and my work is used cardboard in a variety of sizes and vintages. I have several boxes that are many many years old, some even decades, and the paper has patina and stains that I am eager to use in my work. But cardboard does not need to be old. Most of it is constructed from brown paper, but occasionally you will come across white or another color core. Pull the top paper away and enhance with paint, pencil or chalk. This ubiquitous material adds a sensual quality to an otherwise quiet picture plane.

I stumbled on this beautiful box at a flea market and asked the vendor how much he wanted for it. Turned out he thought it was trash and was planning to throw it away, so he gave it to me. Score!

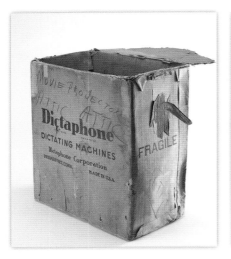
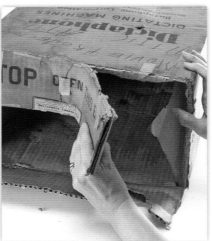
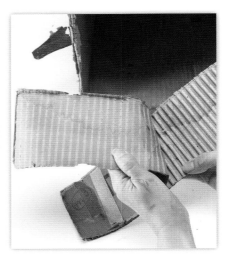

I begin deconstructing the box by pulling the flaps away, marveling at the deep rich patina that age has given it.

The layers are already beginning to delaminate, so I help it along by carefully but firmly pulling the top layer away from the corrugated middle.

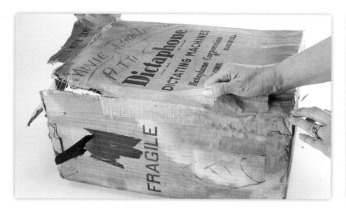

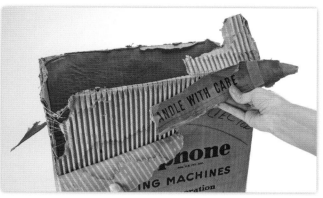

My heart races to see such things as this old tape along the edge of the box, and my mind is already imagining it combined with some of my mark-making papers!

There are so many possibilities in this box.

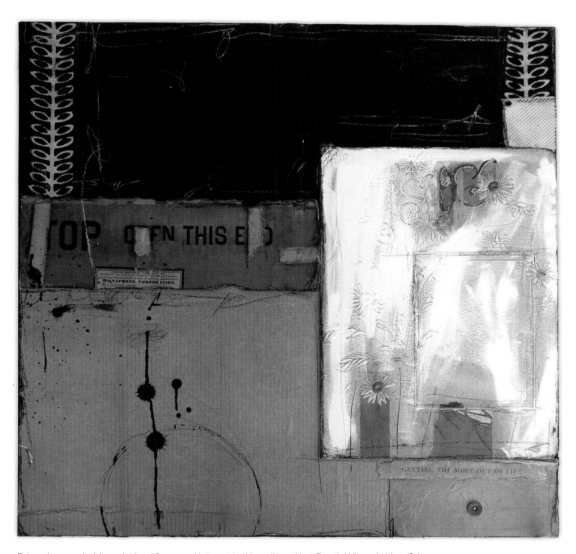

Drips, rings and white paint lend flavor and interest to this collage titled *Death Where is Your Sting*, but that strip at the center-left of the work—salvaged from the flap of the old box I found at the flea-market—truly has my heart.

Greeting Cards and Embossed Material

Old greeting, birthday and holiday cards are another great resource that can be overlooked if the design is deemed undesirable. But what about using the inside or the back of the card? One common mistake in collage is the use of too many layers and having pattern and text on each one. Offering an expanse of neutral coloring without the distraction of a lot of text is soothing and allows the eye a place to rest. Revealing the tiny company logo on the back of the card or the reverse imprint of the embossed pattern can lend intrigue to the work without overwhelming the senses.

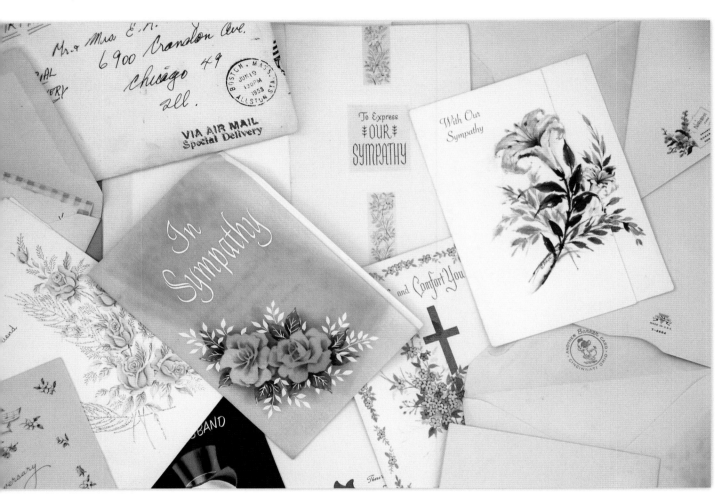

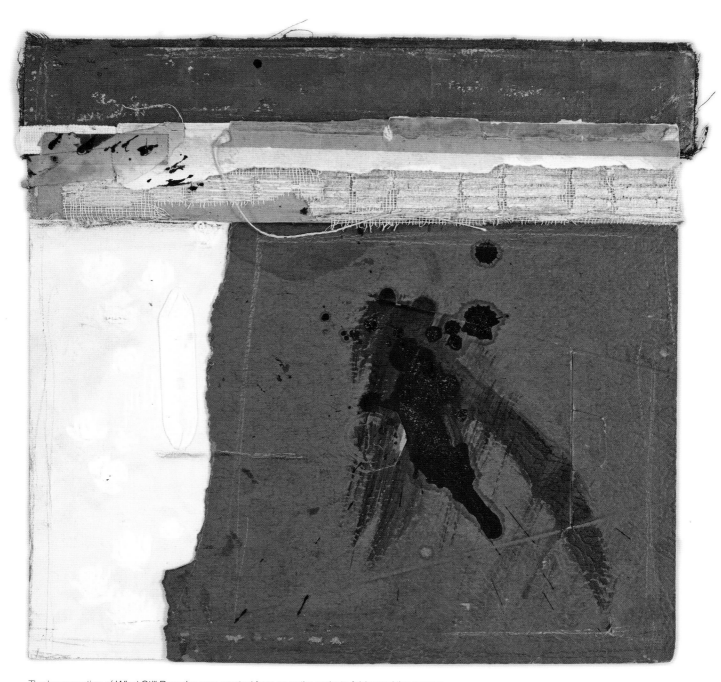

The lower portion of *What Still Remains* was created from an antique photo folder and the reverse side of a vintage sympathy card. The ink was both brushed and splashed on to create a sense of movement. This disruption of the otherwise calm palette is repeated on a smaller scale in the band across the top to the left. This band contains textural and other elements salvaged from an old book, along with the smaller components created while preparing papers with ink.

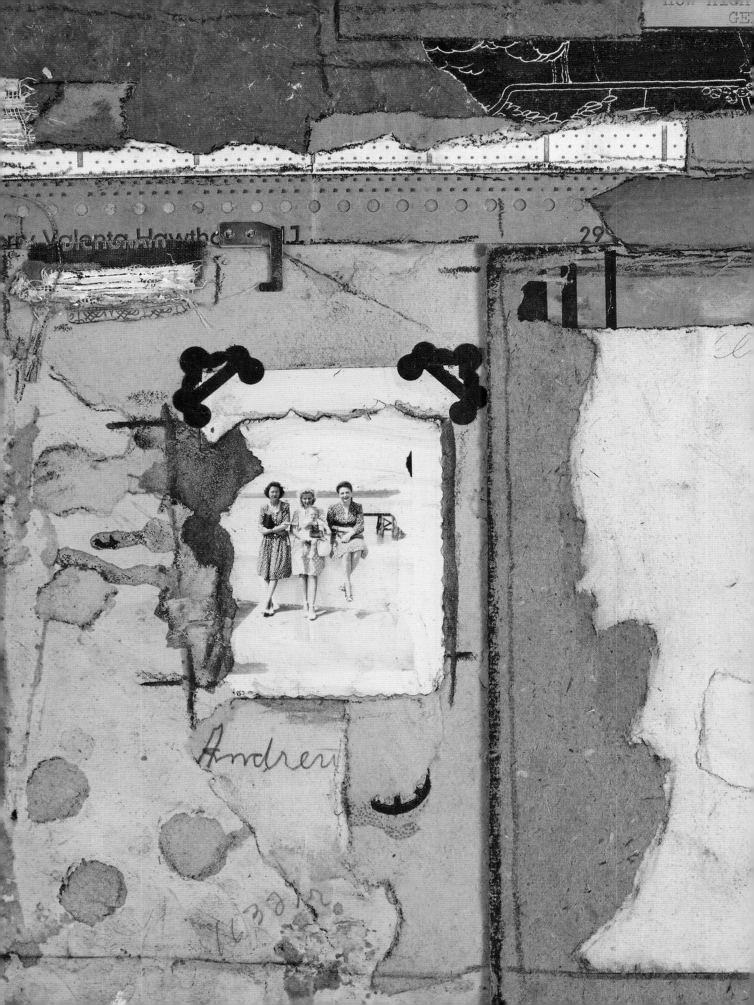

Composing

Understanding the Elements of Design

Composition is the art of arranging in a decorative manner the diverse elements at the painter's command to express his feelings.

— HENRI MATISSE

A good collage composition can be both complex in the use of materials yet simple in design. I trust what I feel subconsciously, but that is not to say I am not conscious of my decisions. There are rules governing the layout and design of a page that can create a pleasing work, but the rules will only get you so far and their implication is that you must do it a certain way to be good. But ask a great composer about the secret to his success, and you'll hear about the emotions that are poured into the music more often than his great grasp of music theory. There is something to be said for working from a place that supersedes the rules and connects to the work at a visceral level.

This is an especially challenging idea for those of us who don't like to lose control, but in a sense, being in control is about avoiding being afraid. To fully tap into your intuitive self, you have to acknowledge the fear and move forward in spite of it. I experience quite a range of emotions when I work, and fear is sometimes one of them. I may be working on a collage that I love, but I know I want to do some mark-making on it; fear of messing it up can keep me from taking another step if I let it. It is okay to be afraid as you create. Feel the fear and create anyway.

In the workshops I conduct, I almost always start with a few exercises designed to allow the students to loosen up and let go of that fear or need to control the outcome of their work. To have the ability to trust what your eye tells you is good, it can be helpful to have a general understanding of the basics of design and composition. What it means, for example, is for your work to have balance or how to decide where to place each of the components and determine what size each should be. But getting too caught up in forcing the work to tell a specific story or have a particular design can actually stifle the creative energy and block the intuitive flow, resulting in less satisfying works of art in the end.

This section is designed to give you a very brief and basic grasp of the rules of design and then, just like the beginning of my workshops, I will ask you to let go of those rules and set aside your fear, allowing your intuition to be your only guide.

Basic Elements

Unity and Harmony

These are similar terms with similar meanings. When a collage has unity, all of the pieces relate to each other in some way. This may be through color, theme or shape.

Harmony comes through when these relating pieces flow in such a way that the eye is uninterrupted and the brain is pleased or comforted.

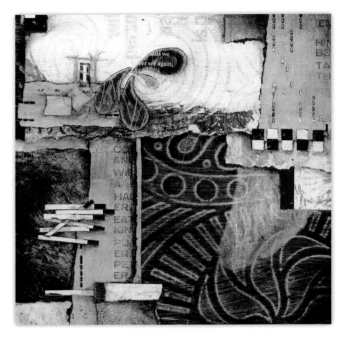

Artwork by Laura Lein-Svencner

Balance

Balance can be achieved in a symmetrical or asymmetrical way. *Symmetrical balance* is weighted equally on both sides of the canvas through objects that are similar in size, shape, color and texture. They may even be mirror images or the same object repeated on either side of an imaginary line.

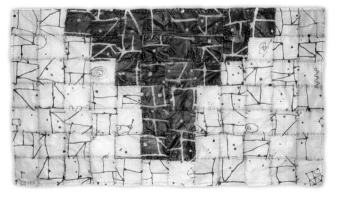

Artwork by Susan Stover

Asymmetrical Balance

Also referred to as *informal balance*, this is more complex to describe and achieve but happens when different elements are placed in a way that is not evenly distributed, but still produces an overall sense of harmony and are weighted equally. Imagine, if you will, a scale with different items on each side weighing approximately the same.

Artwork by Kariann Blank

Line

By its definition in art, line does not exist in nature but describes the mark between two points on a canvas. It pertains to the outline of an object, the use of the marks made in art and is used to define shape or lead the eye in two-dimensional art.

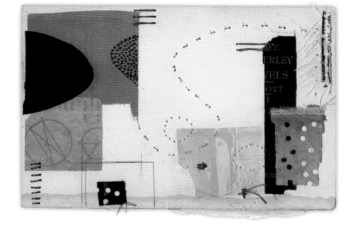

Artwork by Melinda Tidwell

Focus

This refers to the area of the collage where the viewer's eye naturally wants to rest. It can also be described as the focal point in the work, an anchor to keep the viewer from feeling as if the work has no purpose.

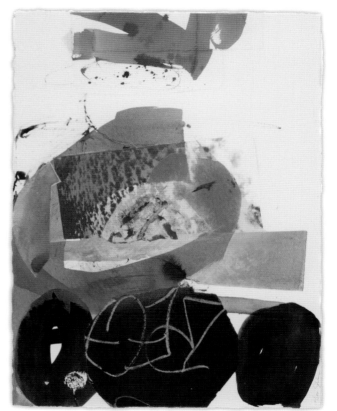

Artwork by Fran Skiles

Contrast

Contrast refers mainly to the color combinations utilized in a work. It is achieved through the use of opposites. An all-white composition, for example, may have harmony but becomes more dynamic to the viewer when a black element is included.

Artwork by Elizabeth Bunsen

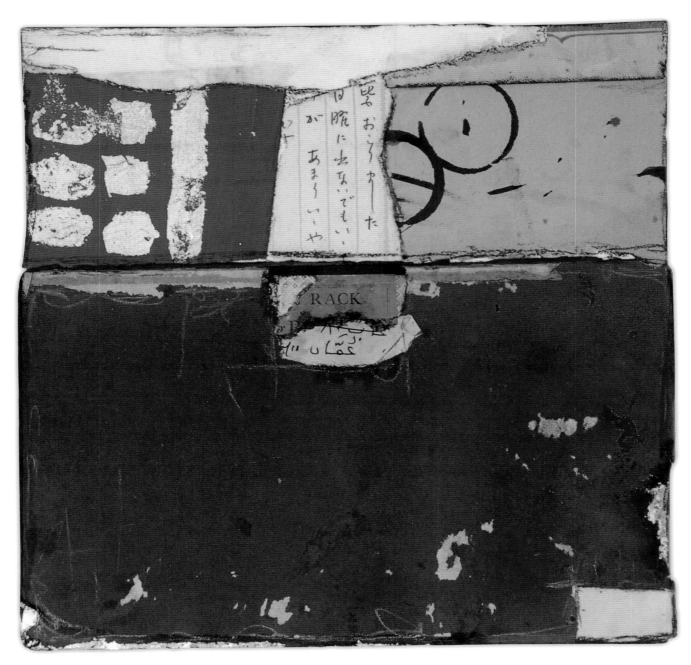

The Writing's on the Wall features two elements that came from a day of mark-making play, preparing papers in the studio. The top left is an old book cover with gold leaf and to the right is paper that had been stamped with ink in a circle pattern. These graphic elements create quite an impact when combined with fragments from an antique Japanese letter.

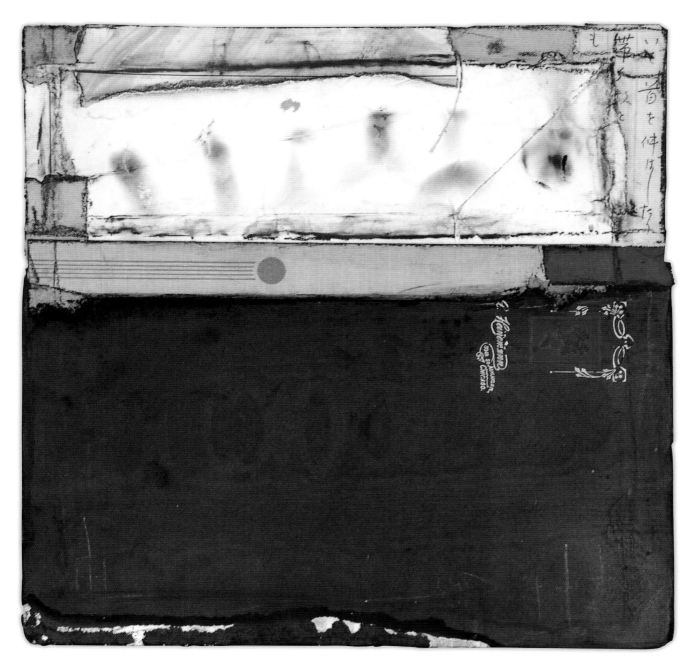

The white expanse at the top of *Sunday's a Comin'* is a recycled shopping bag with marks from the flame of a candle. Above this is a paper from an old blueprint that I have marbled with black India ink. Another fragment of the antique Japanese letter complements these two papers, along with bits of yellow canvas torn from a book cover. The large brown expanse at the bottom is the cover of an old photo folder highlighted with blue paint and topped with another bit of photo folder.

The Gluing Process

As we work through some of the processes of design in this section, we'll begin using glue to secure our prepared elements as we work. The term *collage* is derived from a French word meaning "to stick to or glue." Many an evening will find me sitting at the dinner table when my husband reaches across to pull something from my hair—a scrap of paper that has escaped the work table through gluey fingers absentmindedly sweeping stray locks out of my eyes.

Though there are other ways to secure your composition—sewing or tape, even staples will do—gluing is at the very heart of what it means to be a collage artist! Let's take a look at the basic process I use when I work.

What You Need

baby wipes

collage elements

glue pad

paintbrush, coarse natural bristle

rice bag (for weight)

scissors

watercolor paper

waxed paper

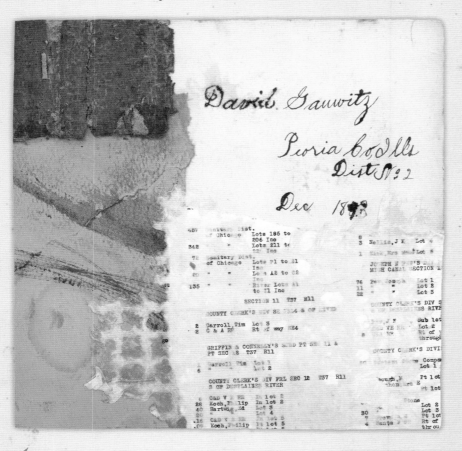

1 Begin laying out your collage on one piece of watercolor paper. Trust your eye to tell you when you feel the composition is pleasing. Do not try to force the message; just allow for a free-flowing style of choosing from your material and laying it out, as if you are putting together a jigsaw puzzle. You will know when the pieces fit.

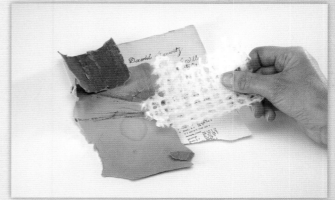

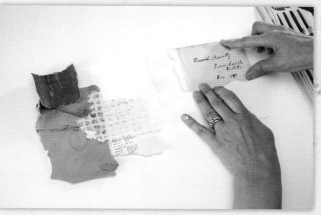

2 Once you have arranged the pieces to your satisfaction, you are ready to glue them down. Use a second piece of watercolor paper to glue everything to so you don't lose track of the composition while you work.

3 Working from one side or corner of the composition, choose an element and lay it face down on a glue pad. Using a coarse natural bristle paintbrush, apply the adhesive in a thin, even coat. You only need a little when gluing paper to paper.

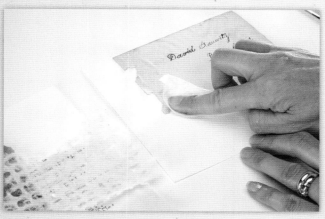

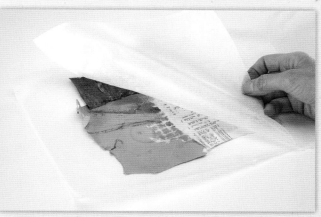

4 Position each piece in its place on the blank watercolor paper and continue until the entire arrangement is complete. Do not worry about fitting perfectly within the substrate; you will trim the overhang when it is dry.

5 Wipe excess glue from the surface with a baby wipe. Place the collage on a flat surface between two pieces of waxed paper.

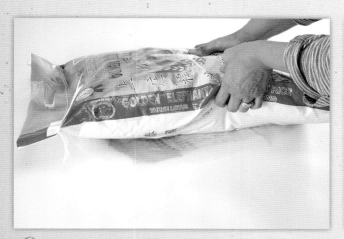

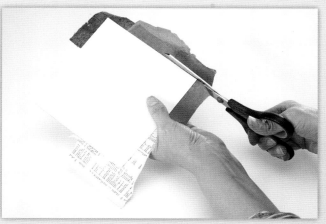

6 Cover it with a large rice bag to flatten it as it dries.

7 Once dry, turn the collage over and trim.

Rules of Thirds and Odds

Rule of Thirds

The rule of thirds is a compositional principle in the visual arts that divides the canvas into nine equal sections and uses the four intersecting lines as guides for placing the subject matter to create a pleasing and interesting layout. This principle works well for realistic compositions—a landscape where the horizon falls along the line of the bottom third and a child flies a kite at the far right vertical line and intersection, for example—but it can also create beautifully designed layouts for abstract works.

What You Need

collage elements including paper with text

pencil

ruler

watercolor paper (or other substrate)

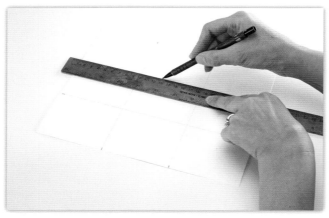

1 Using a ruler, draw lines horizontally across the substrate to divide it into three even sections.

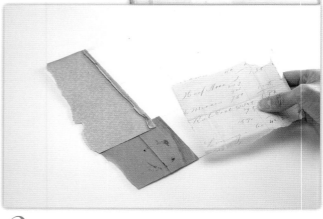

2 Repeat with vertical lines so you have created a grid with nine sections. Lay out your collage papers and ephemera using the grid as a guide.

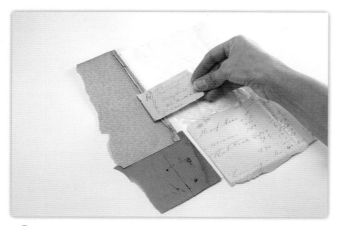

3 Your focal point should be vertical or horizontal at the intersected lines.

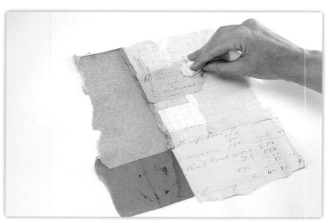

4 Now glue everything in place.

Rule of Odds

One of the simplest ways to make a composition more dynamic is to have an odd number of components, say three, five or seven, featured within the layout. The placement of components in odd numbers prevents the eye from pairing items and keeps it moving across the canvas, which can be one way to create a sense of movement. Because the human eye wants to organize the information it is seeing, it will rest on the middle object when the numbers are uneven, whereas if there were an even number of objects, it would rest in the negative center space. Once the number of objects begins to grow beyond the single digits, it no longer matters whether the number of items is even or odd; it is too much for the eye to take in. When you have a large quantity of similar items to feature in your work, for example photographs or typography, consider grouping them in an odd number of groups.

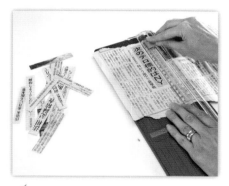

1 Cut multiple long rectangular strips from text.

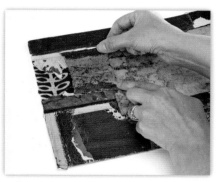

2 Create a background collage on the watercolor substrate with a paper that contrasts the text strips.

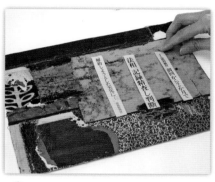

3 Arrange three strips of the text on the background paper.

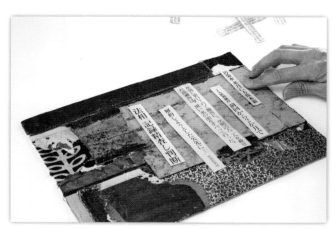

4 Next arrange five strips of text. Notice how the composition changes but still pleases the eye and is interesting to view.

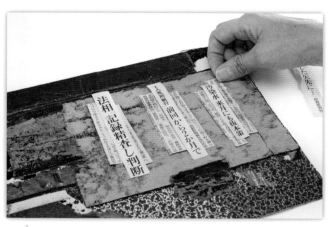

5 Including more objects is too difficult for the eye to separate. Consider arranging larger numbers into three to five groupings of multiple pieces.

Movement and Simplification

The principle of simplification is simply a process of editing when used in collage. With a decrease in the number of components and techniques used, the viewer is more likely to focus on the primary object, and the eye is given the opportunity to rest. Simplification can be achieved through the harmonious use of color as well.

On the other hand, overediting can create a lack of interest and a horrible case of yawning may ensue. Remedy this problem through the principle of movement. Movement excites the eye and engages the imagination as the brain works to interpret the spirit of the work. As noted in the Rule of Odds, movement can be achieved through the placement of elements across the canvas. These elements may be additional layers of ephemera, but they may also be something as simple as a splash of ink.

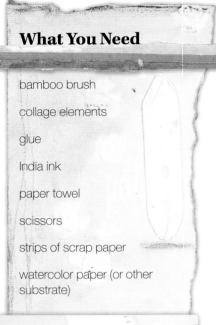

What You Need

bamboo brush

collage elements

glue

India ink

paper towel

scissors

strips of scrap paper

watercolor paper (or other substrate)

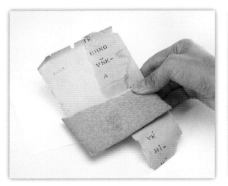

1 Select three pieces of collage material and lay them out in a simple design to cover the substrate.

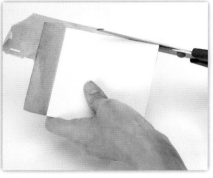

2 Glue the elements in place, trimming the excess when dry.

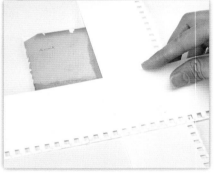

3 Select one section of the collage to work on and mask the other sections off by laying paper over them.

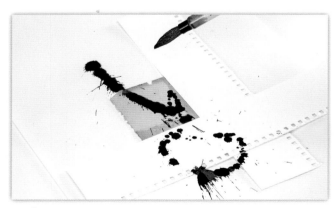

4 Dip a bamboo brush into a jar of India ink. Flick or twist the wrist to create and suggest movement with the pattern of the ink.

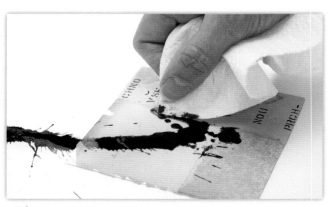

5 Carefully blot excess ink with a paper towel.

Letting Go

Inspiration usually comes during work, rather than before it.

— MADELEINE L'ENGLE

Now that we have had a look at many of the rules and principles of the visual arts, do you know what it takes to create a great composition? Let them all go! It is time to set aside all the shoulds and shants, and dos and dants (okay, it's don'ts, but darned if dant didn't flow better!), and get down to the business of making some art! Unleash that creative intuition, better known as "Your Own Voice," and see for yourself what you can do when you trust your eye to be your guide. As you work through the projects in this book, listen carefully for instruction. It will be a voice inside you that sounds something like this: "I like this" and "I don't like that," "This looks great" and "That makes me feel really good!" Quiet the fears of not doing it right simply by rolling up your sleeves and starting. This project is a good way to do just that!

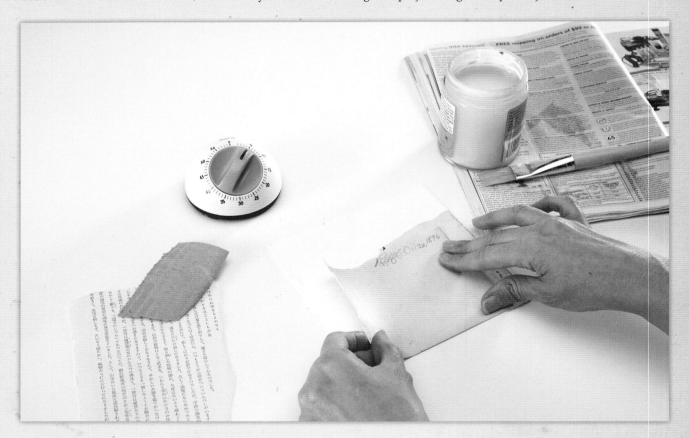

Begin by "shopping" in your collection of ephemera for a small pile that speaks to you today. Don't question it too much as you sort through your scraps; if you feel attracted to a particular piece, just put it in your pile.

Set a timer, giving yourself five minutes to work.

Working quickly, lay out your collage material, trusting your eye and intuition to tell you what looks good.

Begin gluing each piece down as soon as you have a sense that you like the composition. Do not overthink the layout in this exercise.

Wipe excess glue off the finished collage with a baby wipe.

After the collage is dry, trim the excess material to the edges of the substrate.

Sign up for our free newsletter at www.CreateMixedMedia.com.

して、憂さを晴らしてゐるのでした。

なつて行く頃ほひは、いつもさう云ふ癖がついていらつしやいますの

けしきお人のことを忘れず、悲しくばかりお思ひになるのでしたが、宇治の御堂が出

上つたとお聞きになりまして、或る日自らお越しになりました。久しく御覧にならなかつたことで

から、山の紅葉も珍しくお感じになります。取り毀した寝殿の跡に、今度はたいそう晴れ〴〵とし

新しい御殿が建て〻あります。以前の建物はえらく質素な、いかにも聖めいたお方のお住居らし

つたことを思ひ出しますと、故宮が戀しくおなりなされて、ゆかしいお跡を建てかへなければよか

たものをと、後悔の念さへお湧きになりますので、いつもよりも一層しみ〴〵とお眺めになります。

は此處のお部屋飾りが、一部分は優婆塞の宮のおんために佛臭く、一部分は姫君たちのおんために、

らしく細々と、二通りにしつらへてあつたのですが、網代屏風だの何だのと云ふ無骨な品々は、今

の御堂の僧房の調度に殊更寄進なさいました。そして、山里めいた風流な道具類をわざ〳〵調へさ

給うて、費用を惜しまず、たいそう清らかに、風情ありげにお作らせになりましたので、遣り水の

Line and Texture

They say that practice makes perfect and there is merit to that expression, but sometimes what it takes to achieve perfection has more to do with adding a little line and texture. Work that Letting Go exercise until you can feel yourself truly letting go. Allow yourself to play and have fun with it until the cows come home, or at least until it's time to clean up for dinner! Now with a whole shelf full of practice works at the ready, use this next exercise to take them to the next level. With a simple outline of pastel, the components suddenly look more cohesive, and a patch of corrugate or a tease of torn mesh for texture may be just the finishing touch you need.

What You Need

collage elements including some with texture

glue

paintbrush, coarse natural bristle

pastel chalk

protective varnish

scissors

watercolor paper

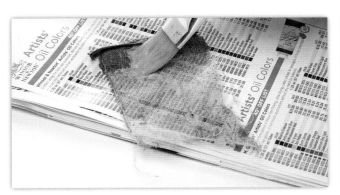

1 Working on a piece of watercolor paper, arrange a composition from the collage material.

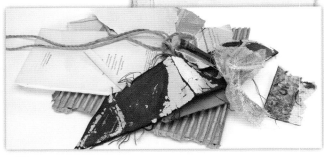

2 Sort through your collage material and find some textural elements to add to the arrangement.

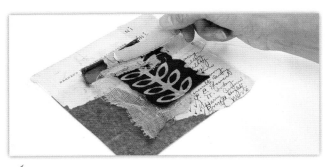

3 Glue each piece into place once you are satisfied with the composition and allow it to dry.

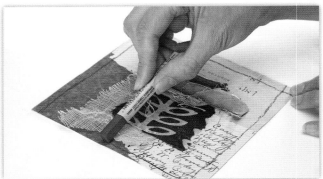

4 Trim the excess. Choose a pastel chalk and outline each component within the composition. Choose a medium hard grade pastel and draw an outline around the entire composition.

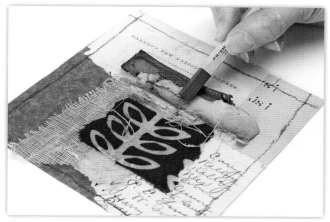

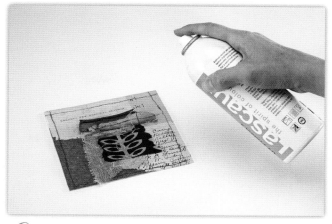

5 Select an element to emphasize by drawing a line over it.

6 Finish the collage by spraying with a protective varnish.

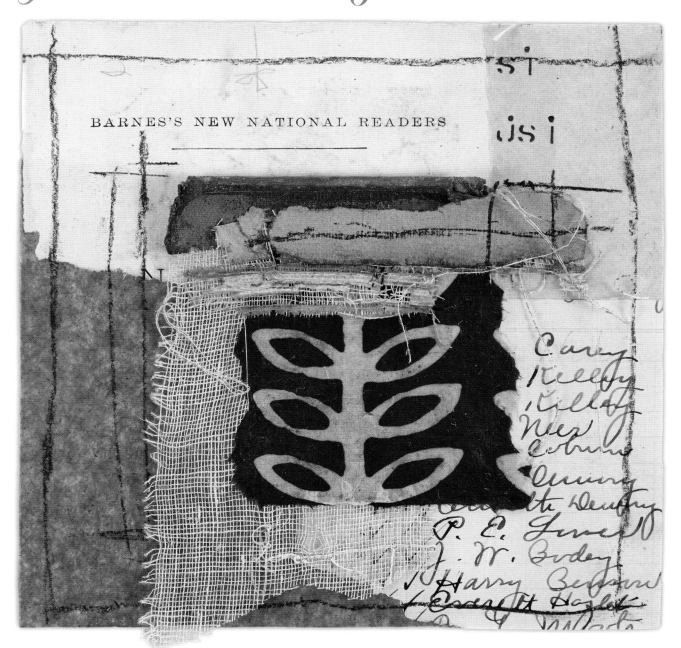

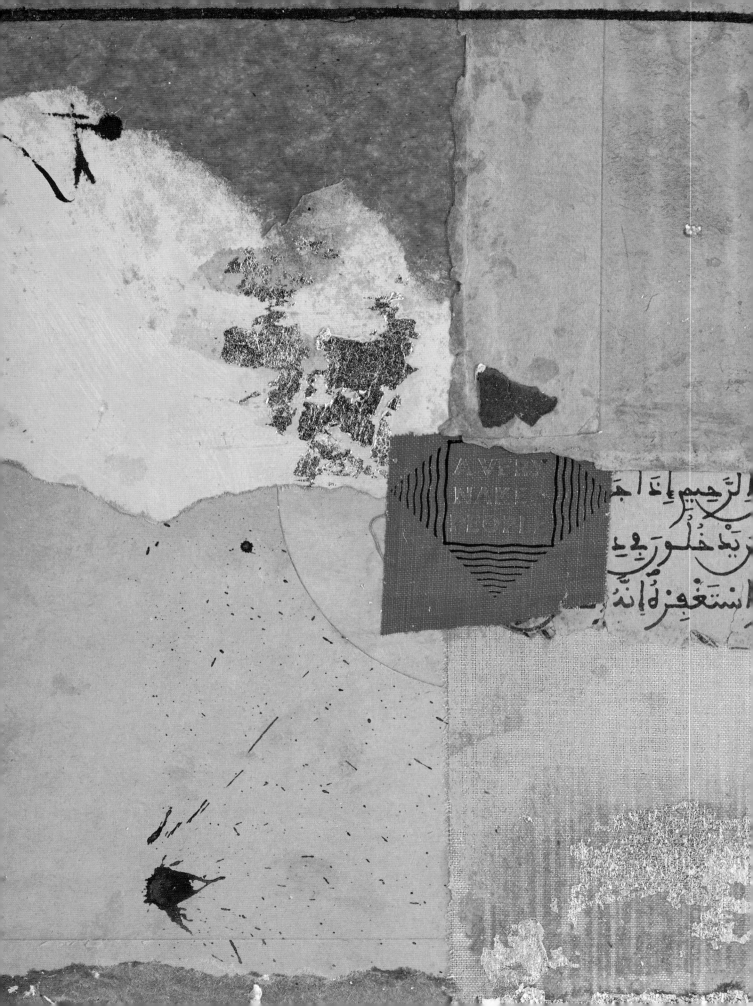

Creating

Exploring the Collage Process

The true work of art is but a shadow of the divine perfection.

— MICHELANGELO

No other activity has served to connect me to my most authentic self than that of creating in the studio. Whether with paint, charcoal or glue, the act of meditating over a work of art has given me the space to explore the inner regions of my life and the impact I desire to make on the world.

A quiet afternoon spent at my work table sets the tone for the contemplative journey into the interior of my mind. I lay out the materials my heart connects to in the moment and begin the process of listening, observing, informing and being informed by the canvas. The dialogue that begins creates a momentum; I am Sherlock Holmes, hot on the trail to solving a mystery. What clues will I find in this pile of scraps? What utterances will rise to the surface as I pull the charcoal line across the picture plane?

I pour myself out in these imperfect bits and pieces with their worn and dirty patina. I wait and watch and wonder what my heart needs to tell. And little by little the broken, disconnected, ugly and ragged give way to the beautiful, whole and complete. The message rises to the surface and I see the reflection of hope, worth and value that it brings.

Mark-Making

There was a time when I would seek out ephemera with handwritten details. I was most fond of old books with messages inscribed to the recipient, a student's notes sprinkled throughout its pages and occasional scribbles by a naughty child. I found these marks to be mysterious and beyond interesting when used in my collages as they seemed to tell a long-forgotten story. At one time these random discoveries were the only mark-making I used in my work. I believed my job as the artist was only to facilitate the story that was already happening within these random scraps and bits of paper I was gluing together. I was the host, ushering the voices of the past into the realm of the present and giving them a forum to speak. But somewhere along the line I realized my voice was an essential part of the story and it was asking to be heard.

Mark-making, at the very core of its definition in art, is anything that makes any mark on a surface. It is a foundational skill necessary in drawing and painting and can evolve into a realistic rendering as technique is developed. A good mark-making exercise can boost your confidence where once you may have felt lacking. It is a therapeutic tool used to express feelings through the intensity of the line or shape of the mark. The use of certain random marks within the composition to capture the artist's energy and intent is highly effective and can make all the difference between a work of art that engages the viewer on an emotional level and one that falls flat.

Mark-making in collage can be a simple highlighting technique designed to unify each of the elements, or a more complex addition of layering through the use of ink, charcoal, graphite or paint. Whether carefully applied with painterly strokes or spontaneously scattered across the canvas in an outburst of emotion, mark-making is a language that adds to the conversation of an abstract work.

As demonstrated earlier in the book, I often prepare papers with mark-making techniques before using them in my collage work, but here we will focus on some simple techniques with basic supplies on the finished composition to create a more dynamic and vibrant work of art in the end.

Graphite Blocks

Graphite, meaning "writing stone," is the mineral originally used to make pencil lead and is a common supply for artists who use drawing as their primary medium. My previously stated obsession with graphite has partly to do with the seemingly limitless uses for it in mixed media and partly to do with its silky, sensual, smooth opacity. Peruse the supplies in my studio and you will find powdered graphite, graphite sticks, graphite pencils, colored graphite and my newest purchase, extra-large graphite bars (XL Graphite) by Derwent. When I purchased these blocks, I had no idea what I would do with them, but I couldn't resist putting them in my cart. I was pleased to discover they can be used as a wet medium and I've been highlighting and mark-making with them ever since.

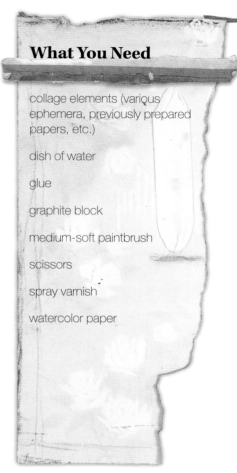

What You Need

collage elements (various ephemera, previously prepared papers, etc.)

dish of water

glue

graphite block

medium-soft paintbrush

scissors

spray varnish

watercolor paper

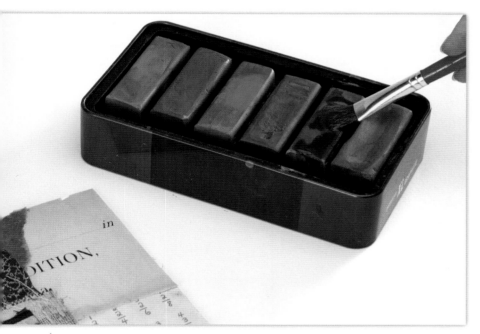

1. Arrange a collage composition on a piece of watercolor paper including some background collage elements that have minimal text or pattern to them. When you are satisfied with the arrangement, glue each piece in place on a second piece of watercolor paper and allow it to dry. Trim the edges neatly. Select an element that you would like to pop. Wet a medium-soft paintbrush and swish it across the graphite block of your choice. Continue to dip in the water and swish against the block until the color liquifies.

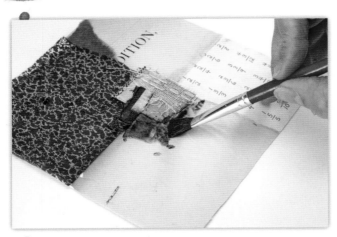

2 Paint the graphite color around two sides of the element you are highlighting and allow it to dry.

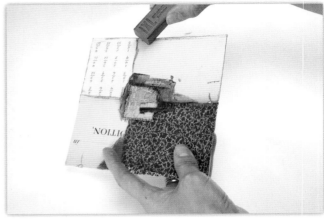

3 Using a dry corner of the graphite block, draw an outline around each of the collage elements.

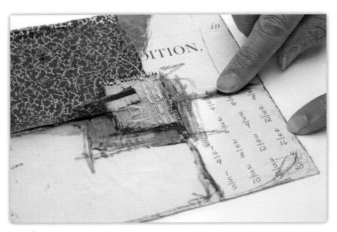

4 Smudge the lines a bit with your finger.

5 When you are satisfied with your design, use a spray varnish to set and protect your work.

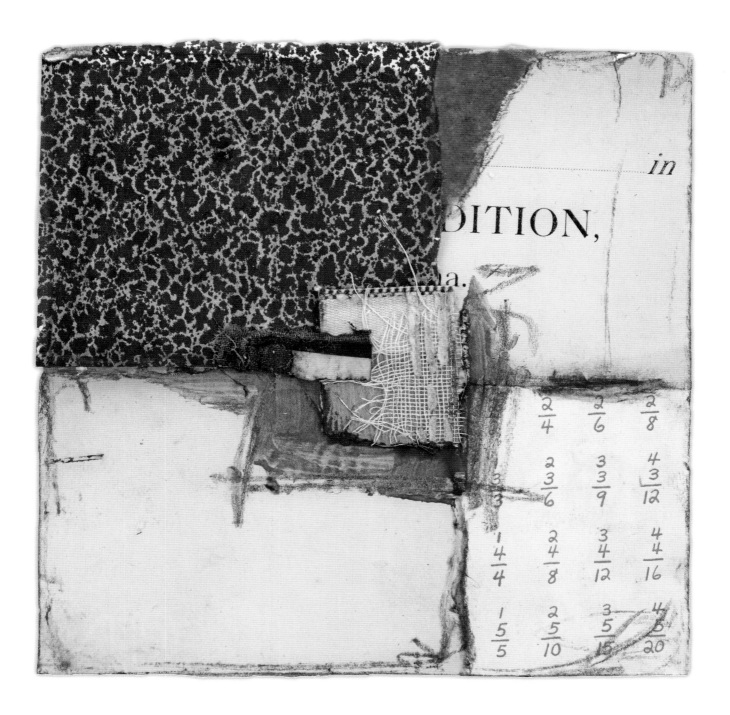

India Ink

The use of ink on paper has captured our imaginations and held our attention on a purely psychological level since the advent of the Rorschach test and the game of Gobolinks that inspired it. Oftentimes, when my work is hanging at a show where I am able to watch the reaction of the viewers as they pass by, it is these drips, highlights and rings that first grab a person's attention and draw him in for a closer look. A memory is evoked or the senses are stirred and a human longing for connection compels each person to add to the narrative of the work as they identify with the splash or shape and relay what it is speaking to them. In this way, the story, storyteller and listener are equal partners and essential to completing the work.

What You Need

collage elements (various ephemera, previously prepared papers, etc.)

dish of water

glue

graphite or pastel

India ink

medium-soft paintbrush

paper towel

scissors

scrap paper

small glass jar

spray varnish

watercolor paper

1 Arrange a collage composition on a piece of watercolor paper including some background elements with minimal text or pattern. When you are satisfied with the arrangement, glue each piece in place on a second piece of paper, allow the piece to dry and trim the edges neatly.

Dip your brush into a solution of ink and water.

2 Apply a line under one of the elements on your composition. (See more about working with ink and water together in Chapter Two.)

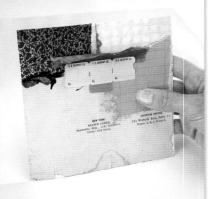

3 Tip the collage and allow the ink to drip and run a bit.

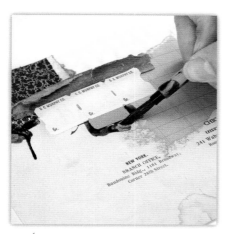 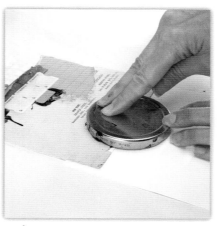 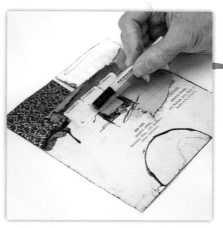

4 Apply more of the ink and water solution around three sides of one of the elements.

5 Blot excess ink and water with a paper towel. Select a section to add an ink ring, and mask the rest of the collage by laying sheets of scrap paper over it. Paint full-strength India ink onto the lip of a small glass jar. Press the inked edge onto the section you selected, twisting a bit to transfer the ink to the paper.

6 After the ink has dried, trace around the collage elements with pastel or graphite. When you are satisfied with your composition, spray a varnish to fix and protect it.

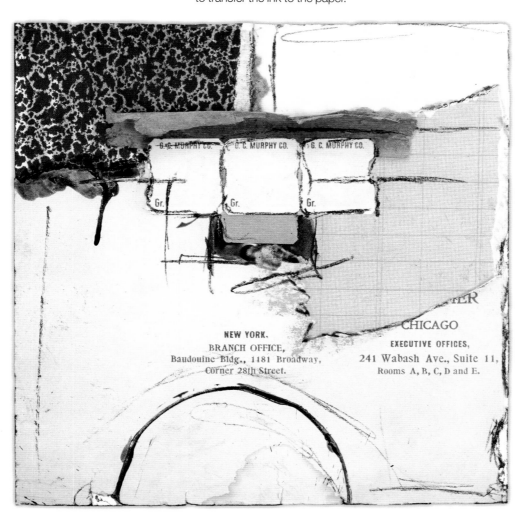

Faux Writing

Sometimes you've got something to say, but you don't really want to say it. Know what I'm saying? The use of script in collage is another thought-provoking way of contributing to the story. Words, however, can sometimes lead the viewer in a literal way that becomes a distraction. There are entirely appropriate applications for using words and true typography in one's work; snippets of a letter or just a glimpse of a song title can set the mood and inform the viewer. On the other hand, spontaneous marks and childlike scribbling can carry a sense of the story while leaving it open to interpretations that are ripe for the double meaning of symbolism.

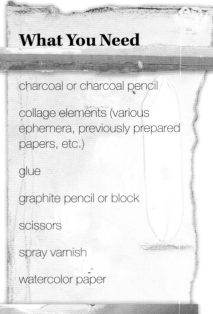

What You Need

charcoal or charcoal pencil

collage elements (various ephemera, previously prepared papers, etc.)

glue

graphite pencil or block

scissors

spray varnish

watercolor paper

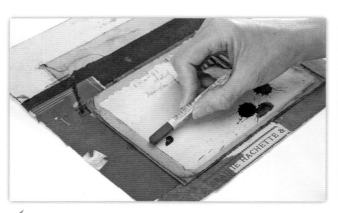

1 Incorporate some background elements with minimal text or pattern into a collage composition and glue to a piece of watercolor paper, trimming the edges neatly when dry. Shade and outline each element with a graphite pencil or block as desired.

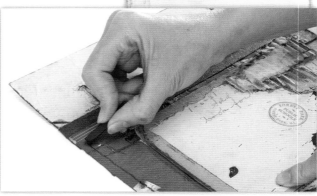

2 Using a thin piece of charcoal or a charcoal pencil, begin by drawing a straight line up the left side of the collage.

3 As you near the top, create cursive-like swirls (imagine you are penning a letter to a friend).

4 Repeat this across the top, or any other area of the composition as you desire, to add interest and give the impression of writing. When you are satisfied, spray a varnish to fix and protect your design.

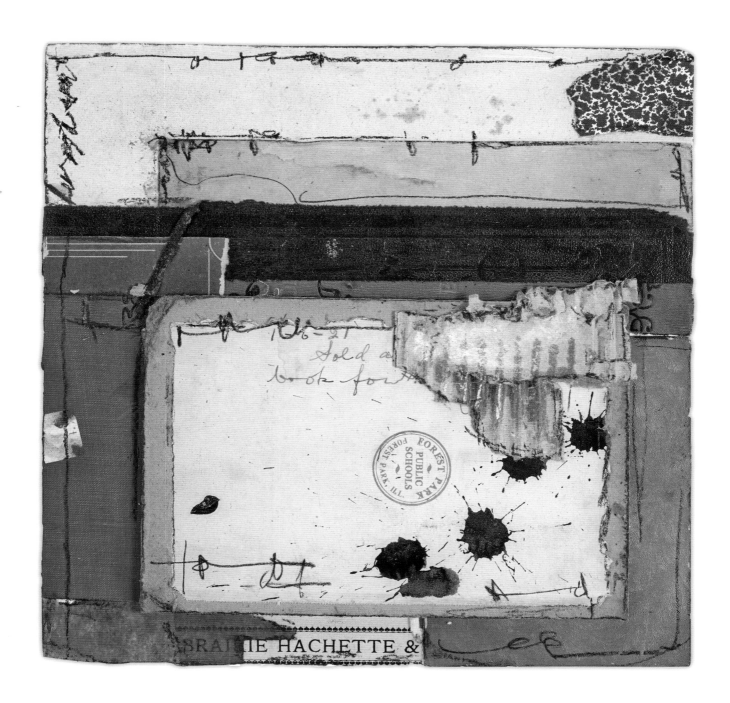

Paint Enhancement

Aside from the scrawls and scribbles and scattered patterns created by pencil and ink, mark-making can include paint and textural elements. While paint falls into the category of traditional mark-making, the lines found in certain textures can give the illusion of a mark on canvas, taking it from a literal stroke of the pen to one rendered through the senses in an almost poetic way. The application of paint to the tactile element can enhance the impression of line or obliterate it, depending on how thickly it is applied.

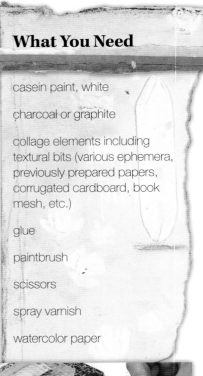

What You Need

casein paint, white

charcoal or graphite

collage elements including textural bits (various ephemera, previously prepared papers, corrugated cardboard, book mesh, etc.)

glue

paintbrush

scissors

spray varnish

watercolor paper

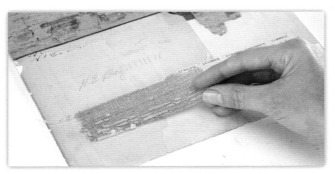

1 Arrange a collage composition on a piece of watercolor paper. Add some textural elements to your composition such as corrugated cardboard, mesh or book spine pieces.

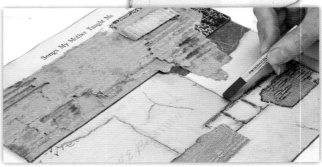

2 When you are satisfied with the arrangement, glue each piece in place on a second piece of watercolor paper and allow the piece to dry. Trim the edges neatly. Shade and outline each element as desired.

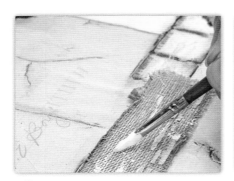

3 Pick up some white casein paint on your brush and apply to the textured pieces, covering as much or as little as your eye tells you is pleasing.

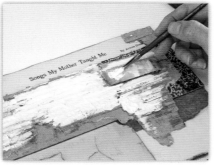

4 Add additional paint over other textured areas.

5 Once the paint has dried, outline the painted area and add lines as desired with a charcoal pencil. When you are satisfied with your design, spray a varnish to fix and protect it.

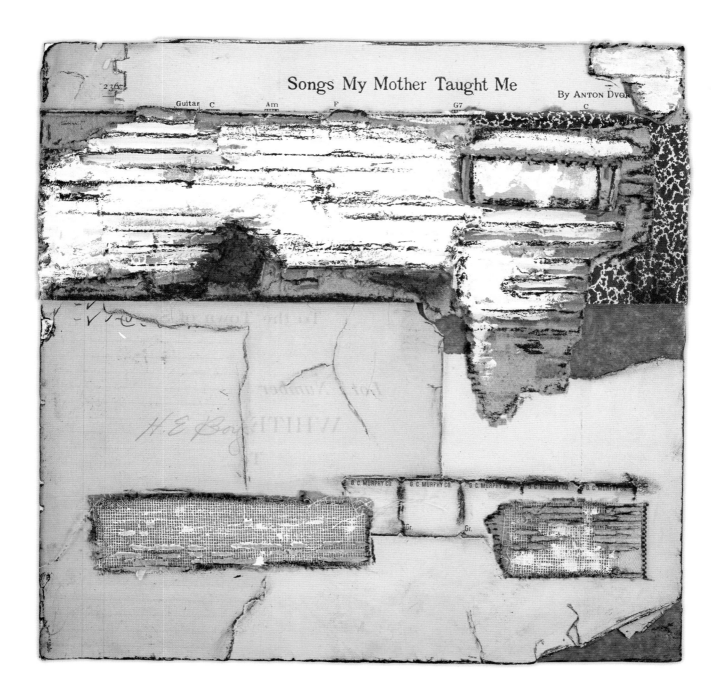

Adding Photography

As I discover more of my own story through this affair of the heart, I begin to notice a flood of collage-like patterns in my surroundings, and the visual imagery in my everyday life leads to an even greater depth of awareness of self and my need to make my mark. I notice patterns in the play of sunlight on the carpet, the newly patched asphalt at a nearby intersection and the landscape of a lakeside park. Certain images are familiar, warm and comforting. Others jar my senses and create a stirring inside me. I want to capture these images and simulate them with paper and glue in semirealistic renderings, or polish them up and incorporate them into a collage complementing their color and line.

It is a crisp early spring morning and I can't help but grab my camera on my way out the door for a photographic treasure hunt, taking note of the response I have to the world around me. This, too, is my intuitive voice at work—these patterns at play, narratives in nature and still-life vignettes. I don't stop to question how I will use each image or why I find them appealing. I let my camera record anything that I feel a response to and create a catalog of images from the day.

Pattern Inspiration

Photo inspiration can be sourced through patterns (created by light or landscape), textures (rust, asphalt, brick) and objects (birds, trees, doorways, etc.). There are myriad inspiring images around us from the objects and items you use everyday to the décor you have carefully chosen for the dining room, to the places outside your front door that attract your attention and draw your eye. Make use of all of this inspiration to influence the color, tone, pattern or light play and balance of your composition. An abstract still life from collage elements can hint at the original scene and even be displayed near it if you work from a vignette study found inside your home.

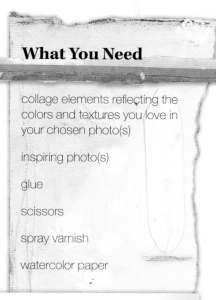

What You Need

collage elements reflecting the colors and textures you love in your chosen photo(s)

inspiring photo(s)

glue

scissors

spray varnish

watercolor paper

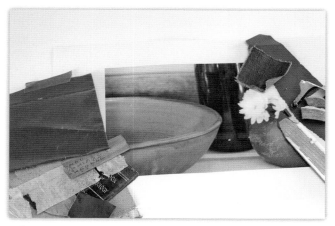

1 Choose your photograph for inspiration and identify the color scheme you would like to work with. Gather collage elements in the range of colors you have selected from your inspiration photo.

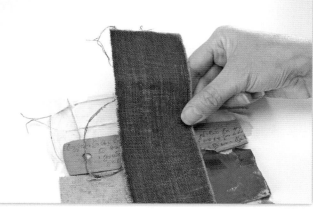

2 Referring to your inspiration photo, begin laying out your elements on a piece of watercolor paper.

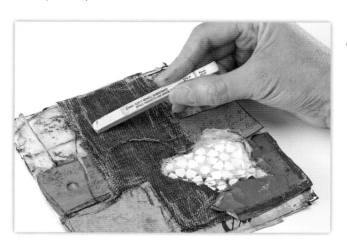

3 Identify the focal point of the photo, if there is one, and determine how you would like to represent it in your collage with collage material, painting with graphite or ink, drawn lines and so forth.

Once you are satisfied with the arrangement, glue each element in place on a second piece of paper and allow to dry. Trim the edges nicely. When your design is finished, spray it with a varnish to fix and seal it.

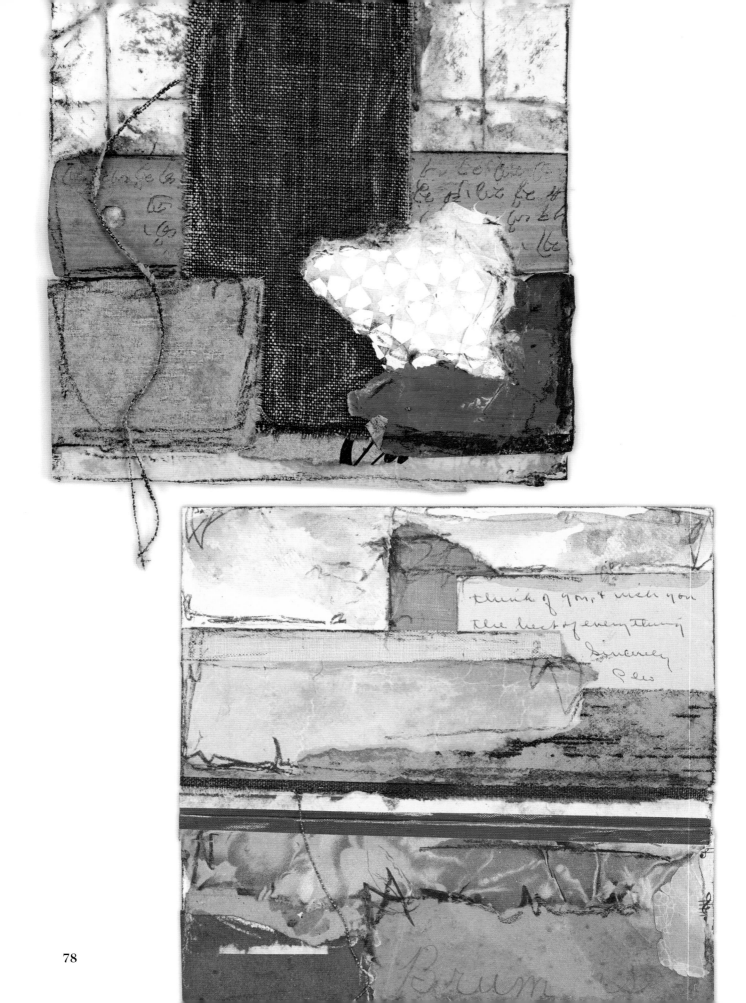

Landscape Inspiration

Many an oil painter and photographer have sought to record the beauty of the countryside around them, setting up their equipment plein air style in an attempt to capture the essence of the scene at just the right moment. Collage artists may be a bit challenged by working in open air by the sea, with the slightest breeze threatening to send their work into the ocean, but that doesn't mean that a landscape cannot be rendered in collage. Grab your camera and head out to the local lake or nature preserve, or get some great shots on your next vacation. Jot down a few notes of the details that particularly catch your attention, and remember to collect ephemera from your trip to use in your work, adding even more meaning to the design.

What You Need

charcoal or graphite

collage elements (various ephemera, previously prepared papers, etc.)

glue

India ink

medium-soft paintbrush

photo of inspiring landscape

scissors

spray varnish

water

watercolor paper

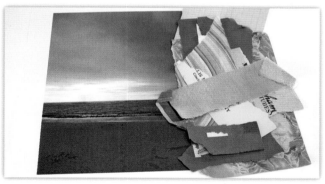

1 Choose your landscape photograph for inspiration and identify the colors you would like to work with. Gather collage elements in the range of colors you have selected from your inspiration photo.

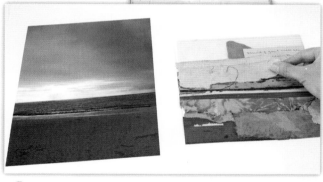

2 Referring to your inspiration photo, begin laying out your elements on a piece of watercolor paper. This can be as real or abstract as you prefer. I am simply mimicking the layers I see in my photograph. Glue and trim.

3 Use a bit of India ink diluted with water to enhance the sky or water areas and add interest.

4 Shade and highlight any areas you feel you want to pop. When your eye tells you the composition is complete, spray a varnish on it to seal and protect the design.

Photos as Part of a Group

"I think that I shall never see a poem lovely as a tree," extols American poet Joyce Kilmer. And indeed, artists of all genres have celebrated the many attributes that are admirable about the tree since the dawn of creation. Rife with spiritual, mythical and symbolic meaning—wisdom, strength and eternal life to name a few—trees have impressed themselves into our minds and senses, and truly, it is difficult not to respond to their majestic elegance.

The images recorded during your photographic explorations are an extension of your intuitive voice. Your eye was held just a moment longer by form or light or beauty. You responded to nature or decay and preserved it in digital form. In this project, allow the image of a tree to inform your creative expression, first through paper, then through abstract painting. You may choose a section of the photograph to represent your use of color and texture, or you may choose to simply let the mood of the image illuminate your process as you progress.

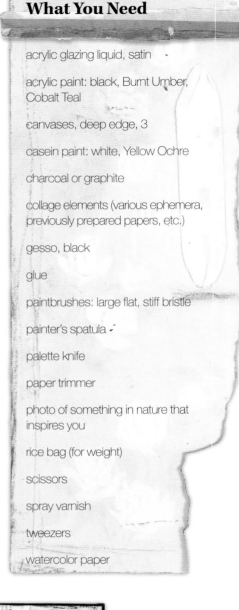

What You Need

acrylic glazing liquid, satin

acrylic paint: black, Burnt Umber, Cobalt Teal

canvases, deep edge, 3

casein paint: white, Yellow Ochre

charcoal or graphite

collage elements (various ephemera, previously prepared papers, etc.)

gesso, black

glue

paintbrushes: large flat, stiff bristle

painter's spatula

palette knife

paper trimmer

photo of something in nature that inspires you

rice bag (for weight)

scissors

spray varnish

tweezers

watercolor paper

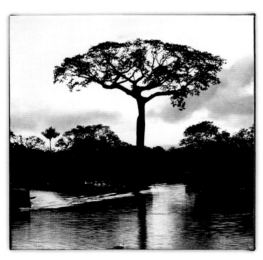

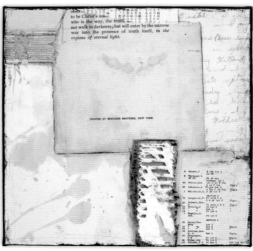

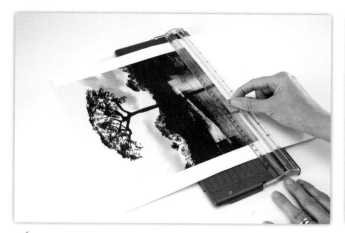

1 Trim the photo to the size of the canvas.

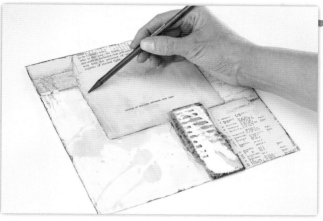

2 Cut a piece of watercolor paper to the size of the canvas, making sure that the edges do not hang over. Create a collage in response to your photograph. Allow your intuitive eye the freedom to respond without overthinking or trying to force the arrangement. Glue each element in place and trim the collage flush with the watercolor paper when dry. Add any mark-making you desire.

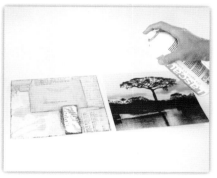

3 Spray the photo and the collage with a varnish to seal.

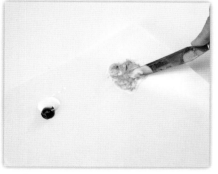

4 Directly on one of the canvases, mix a dab of Cobalt Teal and black acrylic paints with equal parts of acrylic glazing liquid in a satin finish.

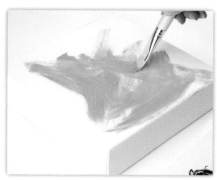

5 Using a large soft flat brush, quickly coat the canvas in the Cobalt Teal color using random brushstrokes.

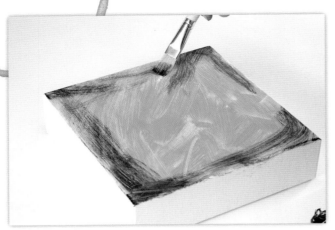

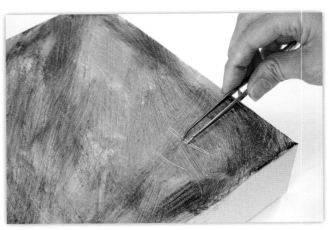

6 Use a dry brush with stiff bristles to apply black paint all over the canvas using very quick and light strokes. Very little paint is needed for this step. Allow the Cobalt Teal to show more in some areas than others.

7 Using another dry brush with stiff bristles, apply Cobalt Teal over the black in random areas. Use tweezers to pick out any bristles that may have come loose as you worked, leaving the scratches visible. (The higher quality your brush, the less an issue this will be; add some scratches anyway!)

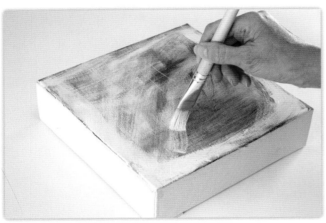

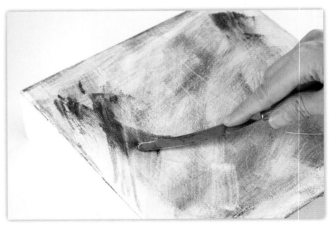

8 Allow the canvas to dry. Apply white casein paint over the entire canvas, more wet and dense in the corners and along the edges, and drybrushing to pull the white across the center, leaving just a hint of the color beneath. Repeat the scratching and picking as desired.

9 With a palette knife, randomly apply Burnt Umber acrylic paint to the canvas.

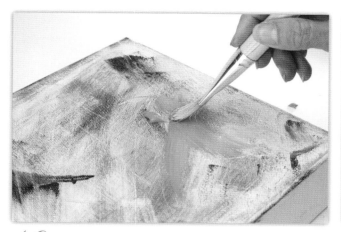

10 Allow the canvas to dry. Squirt a small amount of casein Yellow Ochre paint directly onto the canvas and using a very wet brush, begin to push in and sweep around the canvas. This will cause some mixing with the white and Burnt Umber.

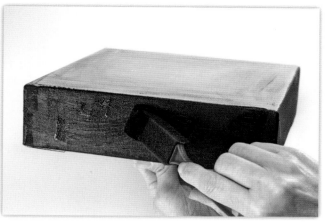

11 Continue adding layers of paint and scratching until you are pleased with the look of your canvas and allow the canvas to dry. Paint the edges of all three canvases with a coat of black gesso followed by a coat of black acrylic paint and allow all to dry.

12 Using a painter's spatula or similar tool, spread glue across the backs of the photo and the collage.

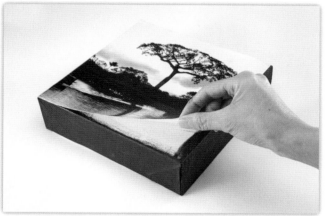

13 Adhere each to a canvas and weight the paper under a rice bag to dry. Spray with varnish to seal and protect your work.

Old Photos as Elements

At one time in my journey as a collage artist, I could not create a work of art that did not have an old photograph as the focal point. I knew my work was telling a story, and I wanted to make it as clear to the viewer as I possibly could. Images and words were often central to achieving this goal, and I spent hours searching for just the right ones. This was an important part of the process of becoming the artist I am today, and I still find myself drawn to these images from the past, but my desire now is to stir the viewer's imagination, tease the senses and draw one into the role of storyteller rather than have the work overtly narrate to the viewer what the story should be.

Art is not what you see, but what you make others see.

— EDGAR DEGAS

What You Need

baby wipe

charcoal or graphite block

collage elements (various ephemera, previously prepared papers, etc.)

found photo

glue and paste

India ink

medium-soft paintbrush

pastel stick

scissors

spray varnish

watercolor paper

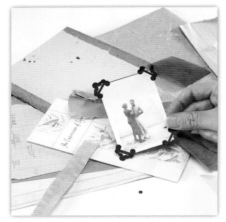

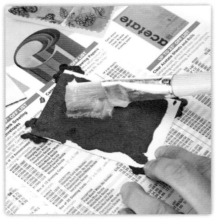

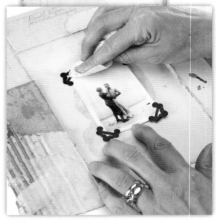

1 Select a found photograph that you find interesting and gather ephemera and collage material to complement it. Try to include at least some neutral material with minimal text to use for the background behind the photograph.

2 Begin to arrange your collage on a piece of watercolor paper including the neutral background material somewhere in your composition. Glue everything in place. Attach the photograph using paste adhesive without diluting it.

3 Use a damp baby wipe to wipe up excess glue that may have oozed out from the edges of the photo.

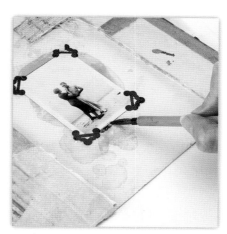

4 Once the collage has dried, trim the edges neatly. Using diluted India ink, run a line under the photograph with a soft brush.

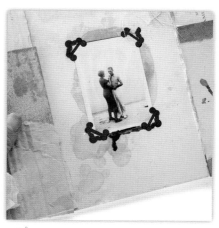

5 Tip the collage for a few seconds to allow the ink to drip from under the photo.

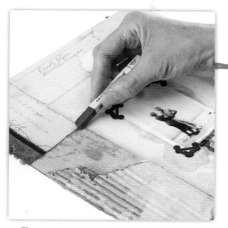

6 When the ink is dry, trace each of the elements with a pastel stick.

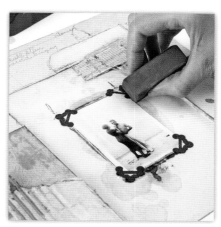

7 Outline the photo and drips with the graphite block.

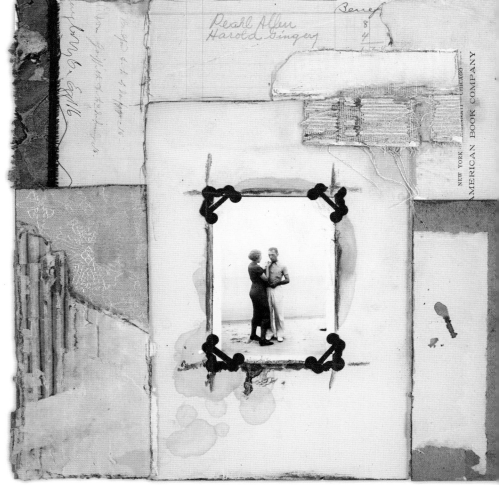

8 Add any other marks you desire; trust your intuitive voice to guide you. Once you are finished with the design, spray with a varnish to seal and protect it.

Creating Depth and Texture

I recently attended an art opening with a friend and her eleven-year-old son, Alex. Standing in front of a tall ceramic sculpture, Alex exclaimed under his breath, "I just want to touch it!" Later, he couldn't help but declare this aloud again as we stood in front of a large encaustic painting. I told him I could relate. Do *you* often feel the desire to touch a work of art when it captures your attention? I know I do.

This need to connect with beauty through the senses is nearly as fundamentally primal as the need for water. It is almost a crime that museums deny this sensual exploration of the great works in front of us and leave us yearning for a deeper communion. On more than one occasion I've been warned about leaning in too close to the works of the great masters at the Art Institute, simply because of the illusion of depth created in the strokes of paint.

Whether through the selection of the papers we use or through the use of gel mediums and paint, texture can leave a powerful impression on the psyche. I'm often tempted to hang a sign in my booth that reads "Please touch the artwork," and when, with these words, I invite the viewer in for a closer look, I am rewarded with expressions of sheer delight.

Acrylic and Gel Medium

The reaction one feels to a work of art does not stand in isolation exclusive to the observer. It is an invisible exchange from the creator to the spectator, an offering of emotions served up with the stroke of the brush. While interpretation may be influenced by the onlooker's own history, using textural mediums in combination with collage allows the artist to imprint her energy and leave it behind—a visible time capsule for all to see. When I am feeling stuck and cannot find just the right collage element to complete a composition, sometimes it is my cue that only gel medium and paint will do.

What You Need

acrylic gel medium

acrylic paint: black, white and other colors of choice

brayer

canvas, deep edge

Catalyst Blade or other mark-making tool

charcoal, pastel or graphite

cheesecloth

collage elements (previously prepared papers, various ephemera, etc.)

gesso, black

glue and paste

paintbrush, large flat

painter's spatula

rice bag (for weight)

scissors

spray varnish

texturing tool

watercolor paper

1 Paint the sides of the canvas with a coat of black gesso followed by a coat of black acrylic paint. Create a collage on a piece of watercolor paper cut to fit the canvas, leaving open space where desired for the gel medium application. Attach the collage with paste.

2 Turn the canvas over and go over the back of the canvas with a brayer to encourage additional adhesion. Weight the collage down with the rice bag while it dries.

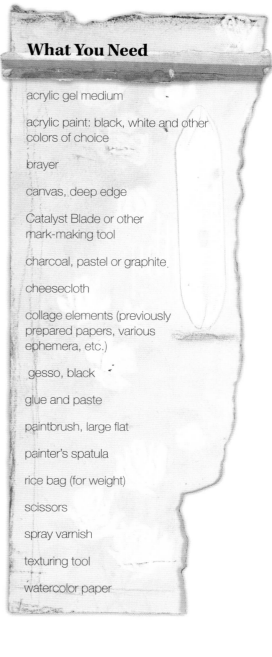

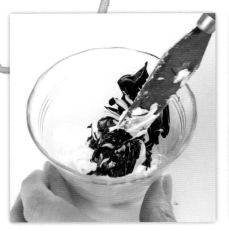

3 Mix gel medium with the acrylic color of your choice.

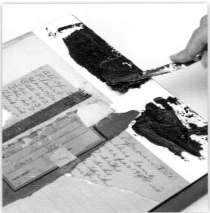

4 Apply the mixture on the open area of your canvas with a painter's spatula or stiff paint-brush, working carefully around the edges of the collage.

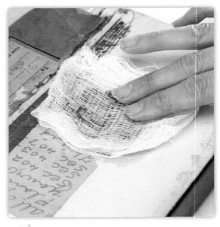

5 Imprint a pattern into the medium by firmly pressing a wadded-up piece of cheesecloth into the wet medium.

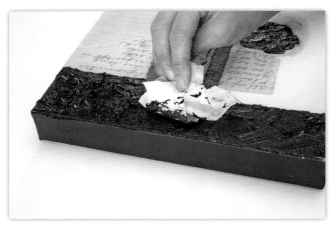

6 Lift up and repeat quickly in an irregular pattern over each of the painted areas, as if you are blotting a spill.

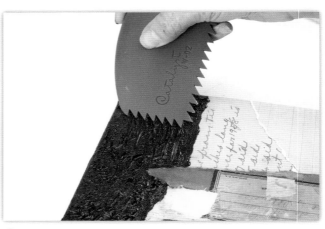

7 Add more texture using a tool designed for mark-making such as the Catalyst Blade.

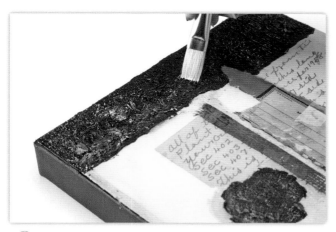

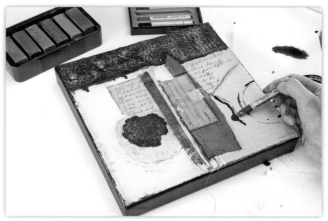

8 Accentuate some of the texture by drybrushing white paint quickly and lightly across the top.

9 Outline the collage elements and add mark-making details to the collage as desired. When you are satisfied with your design, seal it with a spray varnish.

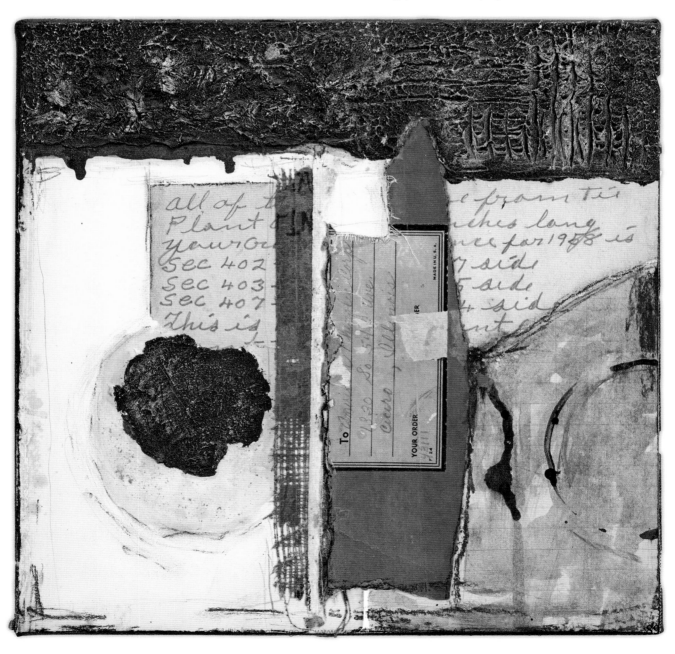

Extending Collage to Canvas

When I close my eyes in worship or in that final moment of time just before I sleep, I am startled by the array of colors playing on the screen of my mind. I yearn to express myself at a deeper level and nothing will do but paint—not in place of my beloved collage but as an extension to it. I love to mimic the grid-like quality of my design with color or create imaginary texture with the stroke of my brush. I challenge the viewer to decide where the paper ends and the paint begins. I sometimes set the tone of the piece to music and add oil pastel to the mix, freely coloring in blocks or swirling a design over the paint after it dries. Impulsive behavior can be frowned upon in our society, but here is one time I challenge you to trust and nurture the inclination to spontaneously try something new.

What You Need

canvas, deep edge

collage work on watercolor paper

glue and paste

graphite pencil

linseed oil

oil paint: Titanium Buff, Titanium White, other colors to complement your collage—especially its edges

oil pastel

paintbrush, large flat

palette knife or craft stick

rice bags (for weight)

scissors

spray varnish

watercolor paper

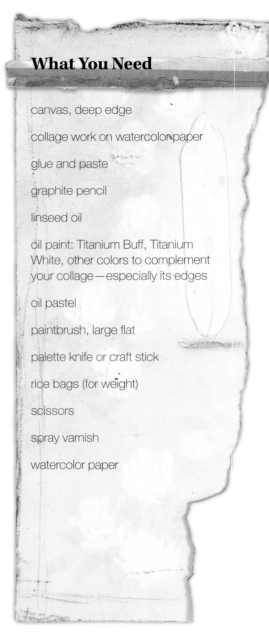

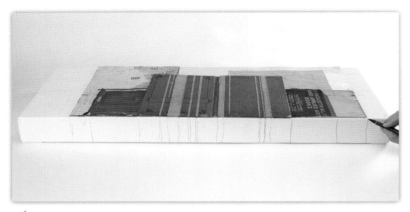

1 Trim your chosen collage neatly to fit within the parameter of the canvas you have chosen to work on. Do not add any mark-making details or affix the collage to the canvas at this point, but lay your collage in place on the canvas and draw an outline around it with a pencil and then block in areas on the sides of the canvas to guide you where you will paint.

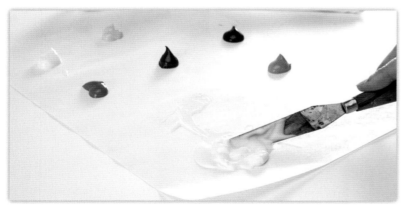

2 Prepare your paint palette with acrylic paint chosen to match or complement the coloring of the elements in your collage, especially those elements around the edges. Mix a dollop of white paint with equal parts acrylic glazing liquid.

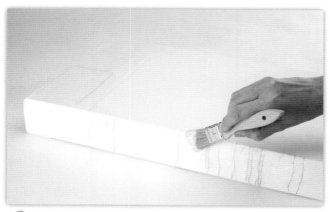

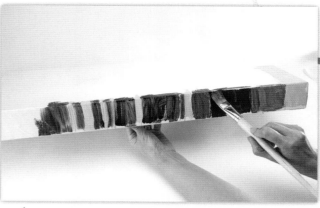

3 Begin with a coat of Titanium White thinned enough with linseed oil to see the pencil marks through the paint. Cover the entire area to be painted with a coat of white thinned with glazing liquid. The pencil marks should show through the paint when dry.

4 Working in progressively darker colors, paint different areas of the canvas wet-into-wet, beginning with the lightest color. Use the same brush for each color.

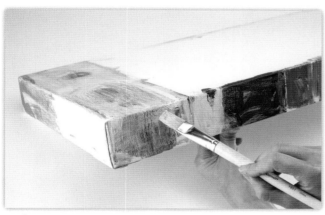

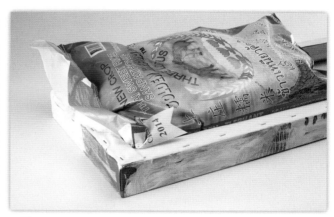

5 Work rapidly and spontaneously blending colors on the canvas and allowing the brushstrokes and indiscriminate nature of the application to show. The idea is not to achieve perfection, but to allow the intuitive self the freedom of expression and allow this freedom to show on the canvas.

6 Set the canvas aside to dry. Once dry, attach the collage to the canvas with paste. (If the canvas is large, turn it facedown and put rice bags inside to weight the collage in place while it dries.)

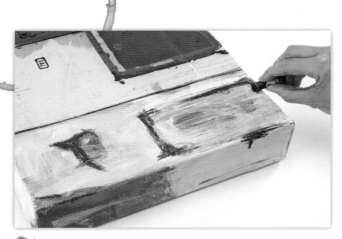

7 Choose an oil pastel to work with and add random marks and details as you feel led.

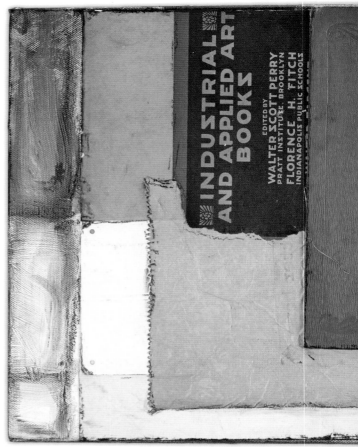

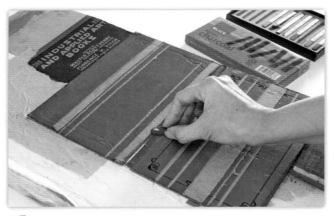

8 Add additional detail to the collage portion of the canvas with graphite pencil.

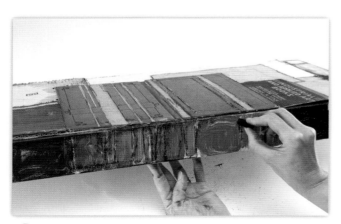

9 Outline areas and shade by drawing on the canvas with charcoal and blending with your finger. Remember the edges of the canvas. When you are completely satisfied with your design, protect and seal your work with a spray varnish.

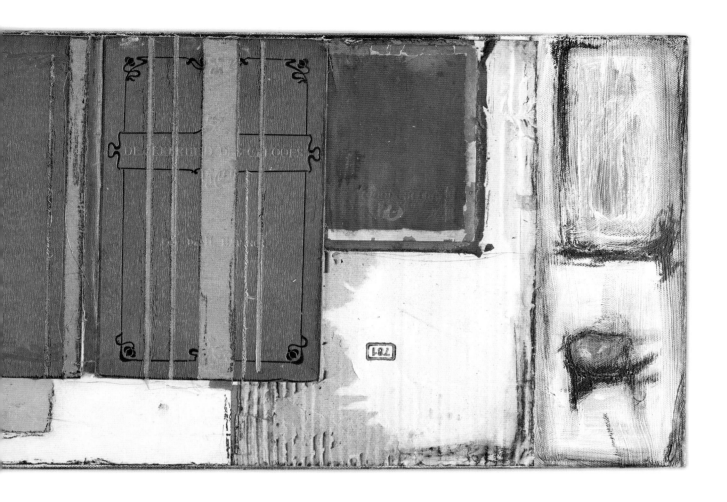

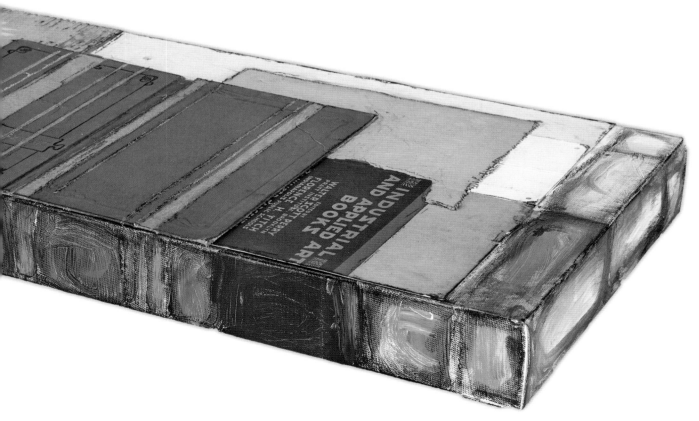

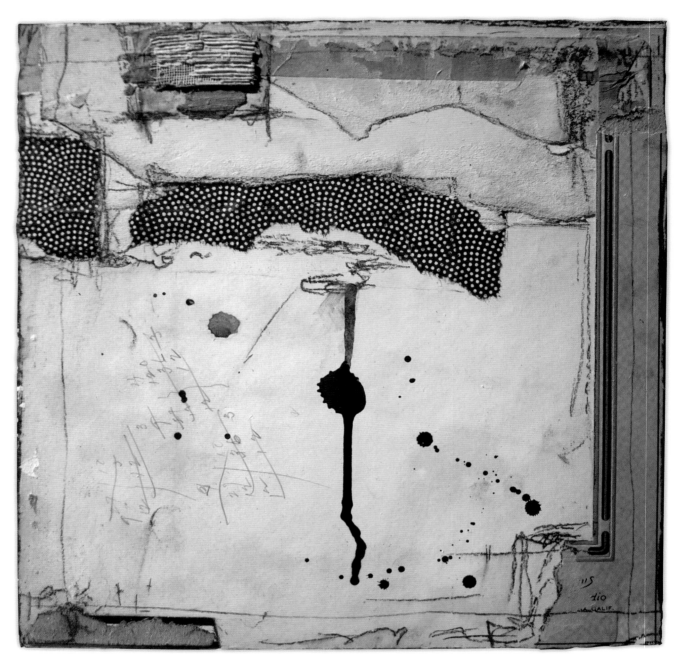

The splashed ink, scribbles and asemic writing in *Love Came Down* are randomly placed among
found notes on an end page of an old book. It is hard to tell what was found and what was created
by the artist. Peeling the pages at the top away from an old chipboard folder created a subtle texture,
which offsets the bit of old book spine nicely. The blue and white dot paper was a gift from a student
in one of my workshops, and I searched high and low to find more of the fine paper.

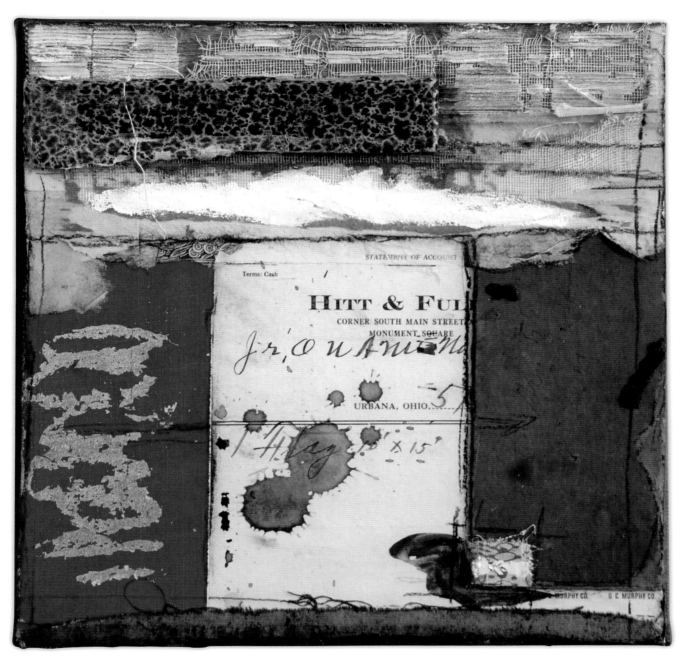

A nice variety of techniques and textures is featured in *Pleased to Meet You*. Gold leaf on salvaged book canvas, splashed ink on an old receipt, and brown salvaged packaging material are topped with a textured book spine and the side of a storage box lid that was covered in marbled paper.

Encaustic Layers

I have come to love and appreciate the remarkable flexibility of encaustic wax as an art medium. For a collage artist, the application of thin translucent layers is a great alternative to using adhesive and can create depth and mystery in a work that is difficult to achieve otherwise. The versatile nature of the wax welcomes experimentation, and I've developed a few unconventional methods of using it over the years. The intuitive voice inside me won't settle for the limitations of the traditional uses, but those uses are a great place to learn to let intuition begin to have its way.

The combination of wax and paper practically demands the artist let go of control. There is no sure way of knowing how each type or color of paper will react when the hot liquid is applied and no going back once the brush touches the page. The results of these sometimes surprising changes can be a stunning array of rich organic tones with a warmth, depth and luminosity impossible to re-create. Unlike paint, encaustic wax cools to the touch and dries very quickly, making it a natural companion for mixed-media projects and the perfect surface to explore. Don't let the unexpected stop you in your tracks. Learn to look at what is happening on the surface in front of you and determine the next thing you can do with what you've got, rather than feel disappointed that it isn't doing exactly what you want.

We will start this section off with two projects designed to get the novice familiar with the traditional uses of encaustic and mixed media. A basic setup of electric griddle, hardware store heat gun, a couple of natural bristle brushes, garage sale loaf pans and encaustic medium and you are just about ready to go. But don't get too comfortable or tarry too long; your best work will come when you are being stretched outside of this zone. The last project in the book is a culmination of all the techniques you have learned. It is here that you will push the boundaries and explore the materials while considering your own deeper story and contemplating the direction you wish it to go.

Good to Know

To save time and keep the experience of working with encaustic less intimidating, at the art supply store purchase a premixed package of encaustic medium that has the damar resin already in it.

Encaustic As a Top Coat

Renovating her childhood home, my mother found a stack of old love letters hidden behind a wall, written to a relative in the 1920s. Time had taken a toll on these carefully tucked away pages, not to mention the mice and moths that had discovered them first. After hanging the series I created from these treasures, the newly exposed to light and air handwriting began to fade, and I set off on a quest to find a way to preserve the script that eventually led me to encaustic wax. Used as a top coat, simply to protect and enhance the papers below it, the smooth surface of the wax nearly sings as it invites the observer to come in for a closer look. There is a sensuality about the wax that lends itself well to the story of collage.

Encaustic wax, created from beeswax and tree resin, is the substance used in the Fayum mummy paintings found across Egypt and dating back to the first century B.C. This stuff was made to last!

What You Need

collage elements (various ephemera, previously prepared papers, etc.)

cradled panel

electric skillet or griddle

encaustic medium

glue and paste

loaf pan (dedicated to encaustic medium)

paintbrush, wide flat (dedicated to encaustic medium)

painter's tape

scissors

scraping tool

surface thermometer

torch (butane or propane)

watercolor paper

1. Create a collage on watercolor paper cut to fit a cradled panel and attach with paste. Cover the sides of the panel with painter's tape.

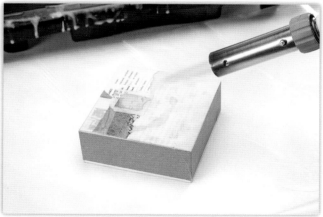

2. Melt the encaustic medium in an electric fryer or a loaf pan on top of an electric griddle or skillet to approximately 175°F–180°F (79°C–82°C). Use a surface thermometer to monitor the heat. Warm the surface of the collage with the torch using quick sweeping motions back and forth across it a few times. Do not hold the torch in one place or you may catch your work on fire!

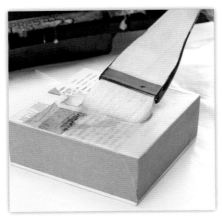

3 Apply a coat of encaustic medium evenly across the surface of the collage with a wide flat brush.

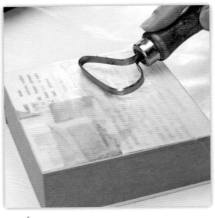

4 Smooth any uneven areas with a scraping tool.

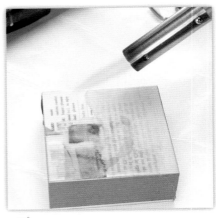

5 Add one or two additional layers of medium, fusing between layers.

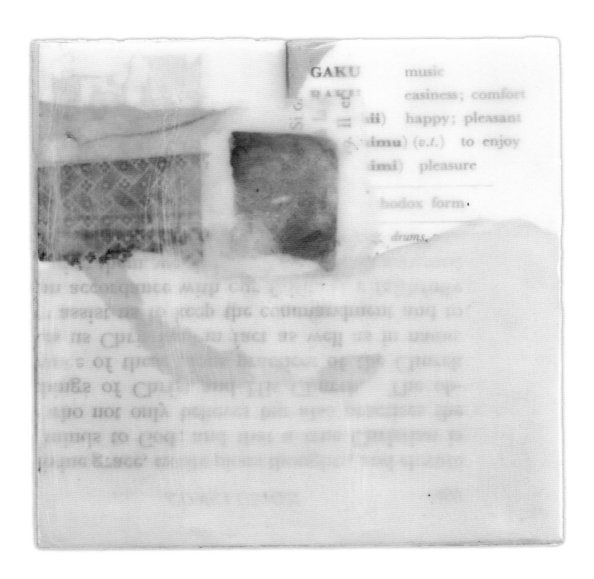

Encaustic and Photo Transfer

I recently read an encaustic workshop description by a highly regarded artist in which collage was considered an advanced technique. To an artist who works mainly in wax, the application and control of the surface of encaustic is the main point and is studied in great detail, but as a collage artist, using wax as an adhesive and adding images to the surface is one of the most basic things you can do. Don't let little imperfections in the surface or occasional bubbles concern you. It is nearly impossible to lay down wax and paper and achieve a completely smooth surface without lots of practice. These imperfections lend themselves well to the eclectic nature of mixed media and can be beautiful additions to your design.

What You Need

bone folder, craft stick or metal spoon

ceramic loop

collage elements (previously prepared papers, various ephemera, etc.)

cradled panel

electric griddle or skillet

encaustic gesso

encaustic medium

loaf pan (dedicated to encaustic medium

long-handled tweezers (optional)

paintbrush, wide flat (dedicated to encaustic medium)

painter's tape

toner-based photocopy

scissors

spray bottle filled with water

torch (butane or propane)

1 Tape the sides of a cradled panel. Paint the surface of the panel with two to three coats of encaustic gesso and allow the gesso to dry.

2 Apply a coat of clear encaustic medium over the gessoed panel.

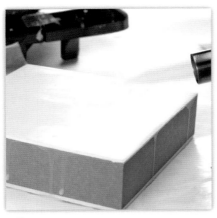

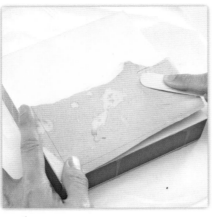

3 Fuse the wax and then repeat with one to two additional layers of encaustic medium, fusing between layers.

4 Position a collage element on the wax and burnish it in place with the back of a metal spoon, a bone folder or a craft stick.

5 Cover the collage element with a layer of wax and fuse.

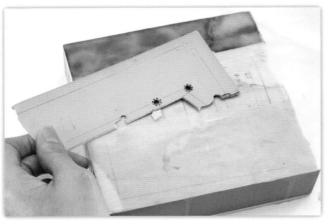

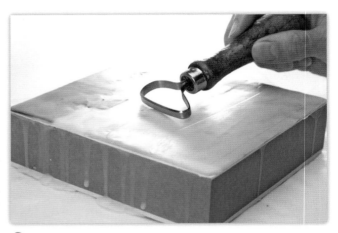

6 Repeat positioning each collage element, covering with wax and fusing until all elements have been placed. (Alternatively, pick up the collage element with a pair of long-handled tweezers and dip it into the wax before laying it in place on the composition. Continue with burnishing and layering same as above.)

7 Using a ceramic loop, lightly scrape the surface to remove any ridges or irregularities and then fuse to smooth.

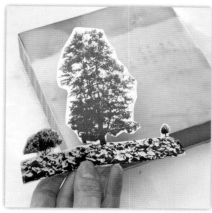 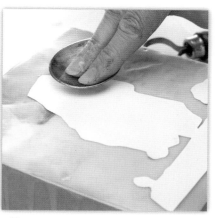 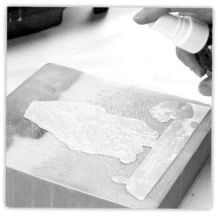

8 Trim your photocopy of any excess paper so you're left with the imagery you want to transfer.

9 When the wax is hardened but still slightly tacky, place the photocopy facedown on the wax and burnish well with the back of a metal spoon. Burnish all the edges and the entire image area repeatedly to ensure the image will transfer successfully.

10 Spray the photocopy with water until the paper is saturated and burnish again with the back of the spoon. Repeat spraying and burnishing alternatively until you see the paper beginning to loosen.

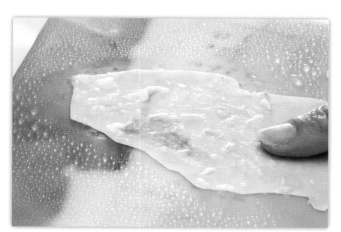 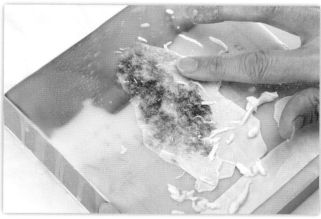

11 Begin gently rubbing the paper with your finger to remove the paper backing.

12 Continue patiently with this process until it looks like you have removed all the paper.

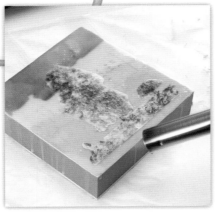

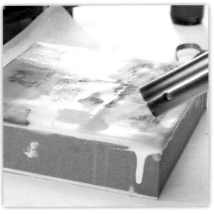

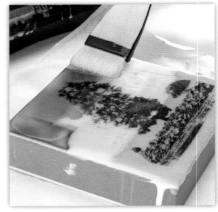

13 Fuse lightly to reveal the remaining paper; it will turn white. Spray the image and repeat the rubbing process to remove the remaining paper.

14 Fuse once more, allowing the wax to swallow any remaining minimal bits of paper. (Do not overfuse or your image will float away in the melted wax.)

15 Apply a new coat of encaustic medium and fuse.

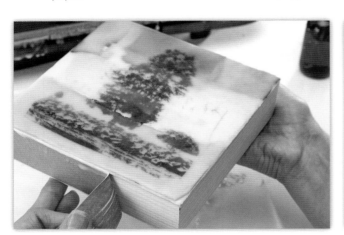

16 Remove the tape from the panel.

17 Use the ceramic loop to smooth the buildup of wax around the perimeter of the panel.

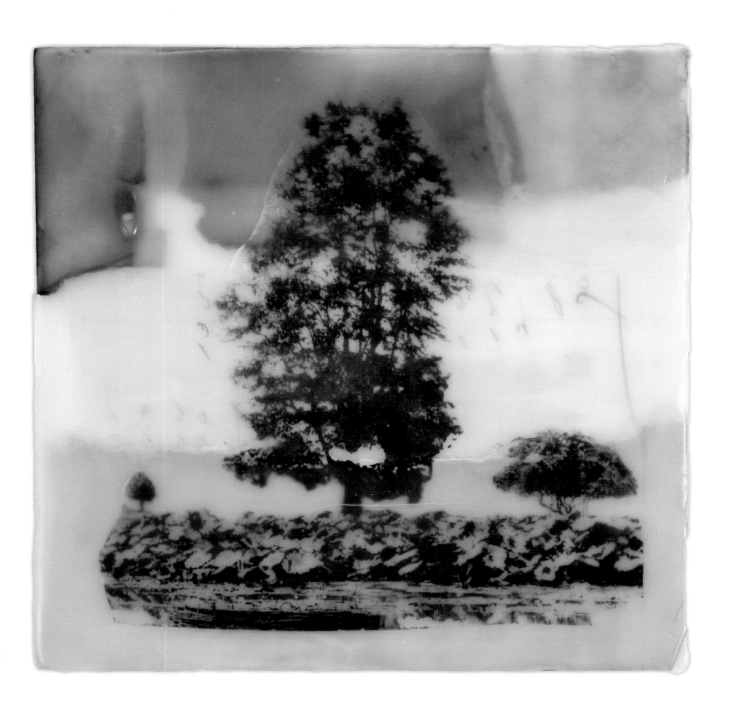

Encaustic and Dimensional Elements

Learning to attach objects to your design with wax is another foundational technique that can have a big impact on your ability to play and intuitively explore your own design potential. Just as effective as a splash of ink in catching the eye of your viewer, adding an element on top of the surface can evoke memories and create a response defying words. From one tiny button embellishing the surface to a larger work featuring a rusted inclusion or a spine of a book, the symbolic nature of an object can spark your idea wheels and get your intuitive self talking like nobody's business.

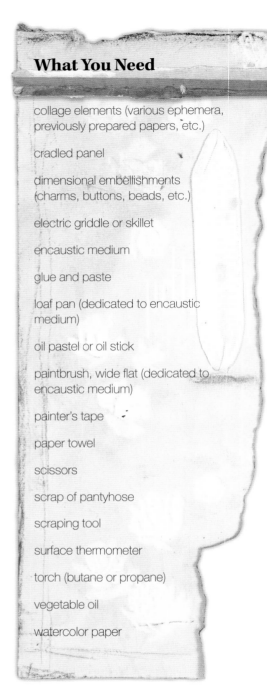

What You Need

collage elements (various ephemera, previously prepared papers, etc.)

cradled panel

dimensional embellishments (charms, buttons, beads, etc.)

electric griddle or skillet

encaustic medium

glue and paste

loaf pan (dedicated to encaustic medium)

oil pastel or oil stick

paintbrush, wide flat (dedicated to encaustic medium)

painter's tape

paper towel

scissors

scrap of pantyhose

scraping tool

surface thermometer

torch (butane or propane)

vegetable oil

watercolor paper

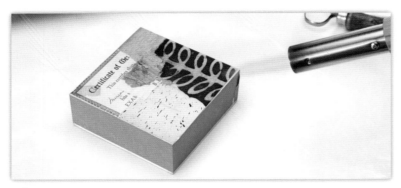

1 Cover the sides of the panel with painter's tape. Create a collage on water-color paper, and cut it to fit the cradled panel. Adhere it to the panel with paste. Melt the encaustic medium in an electric fryer or a loaf pan on top of an electric griddle to approximately 175°F–180°F (79°C–82°C). Use a surface thermometer to monitor the heat. Warm the surface of the collage with the torch using quick sweeping motions back and forth across it a few times. Do not hold the torch in one place or you may catch your work on fire!

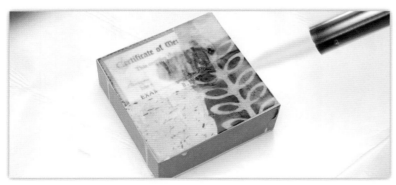

2 Apply two to three coats of encaustic medium evenly across the surface of the collage with a wide flat brush, fusing between layers.

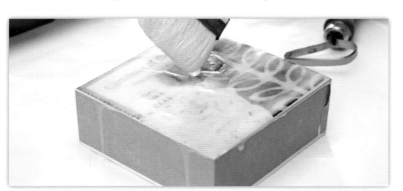

3 Add an extra dab of wax in the area you wish to embellish.

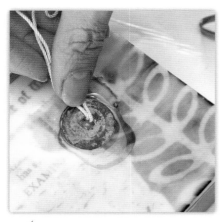

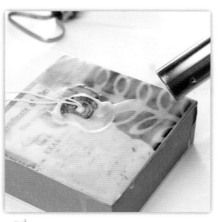

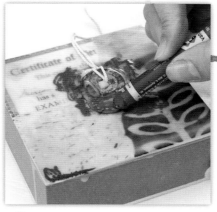

4 Lightly fuse this area, then press your embellishment into the wax while it is still warm.

5 Apply a little more wax to hold if necessary and fuse to set.

6 Use an oil pastel (or oil stick) to apply some color around the embellishment and any other area of the collage you want to add some interest.

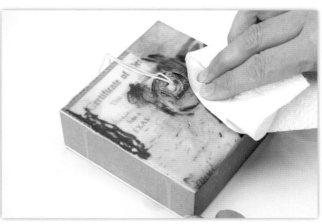

7 Pour a bit of vegetable oil onto a paper towel.

8 Use the oiled paper towel to remove most of the oil pastel color, leaving a subtle amount behind.

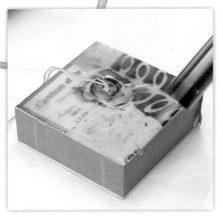
9 Fuse the oil color.

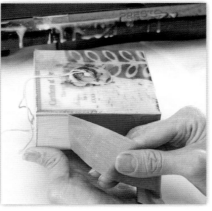
10 Remove the painter's tape.

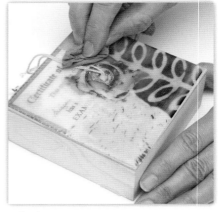
11 The wax can be polished a bit using a scrap of pantyhose.

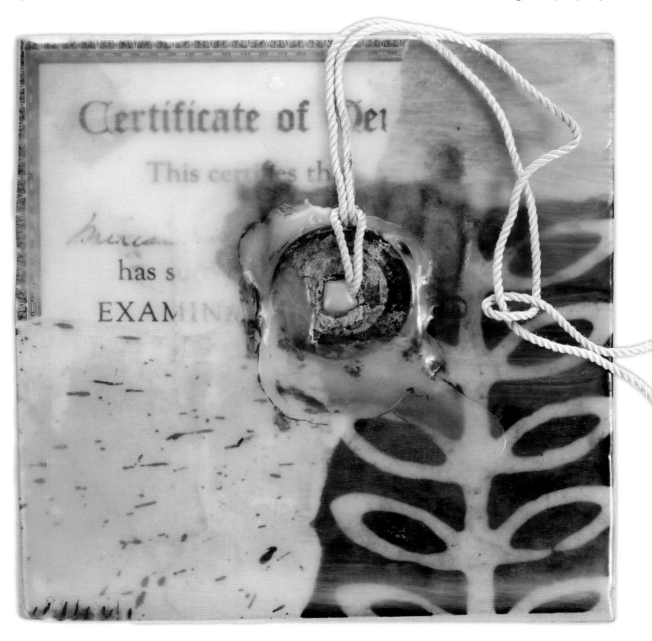

Self-Portrait

Here we bring it all together in a singular work of art that will serve to reflect who you are, where you have come from and the truth of where you most want to be. The wax serves as a drawing surface to a two-dimensional "sculpture" as you scrape and apply chalk, charcoal and ink. The activity of applying a mark and scraping back, then applying again to create a form, becomes a self-portrait. The process frees the mind to dig deep as the tools literally dig into the wax. It is therapeutic, healing and enlightening, not to mention beautiful.

The half of the canvas that has no wax is covered with ink to create a chalkboard effect. The piece becomes a means to release and reframe feelings as you write words that may have been carried as labels at one time and replace with words you sense you are becoming. This is a cathartic exercise that will solidify your identity as an artist.

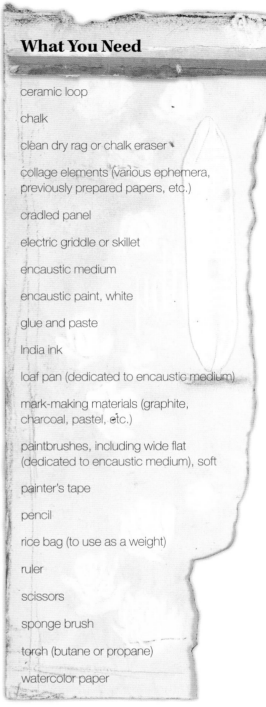

1 Create a collage on watercolor paper cut to fit the cradled panel. The collage elements should be chosen for their shape and subtle texture and not as much for their color.

Draw a line down the center of the collage to divide it evenly in half.

2 Apply painter's tape on the right side of the line.

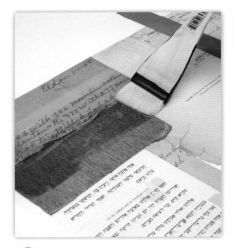

3 Warm the collage up a bit using the torch. Move the torch around to avoid burning the paper. Apply a coat of clear encaustic medium to the left side of the tape.

4 Fuse the wax and then repeat with another two to three coats, fusing between coats.

5 Apply a coat of white encaustic paint over all but one strip on the left.

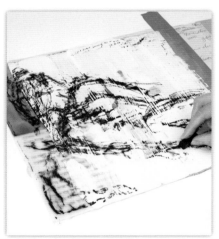

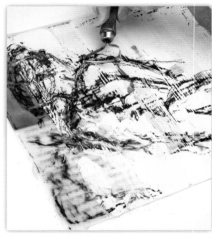

6 Scrape lightly with a ceramic loop to remove ridges and any surface irregularities. Allow the clear to show through in some areas and fuse.

7 Allow the wax to set until it is cool to the touch and then begin drawing a very rough outline of your self-portrait with a piece of soft charcoal or other mark-making material.

8 Thinking of the ceramic loop as an eraser, begin to scrape back some of the charcoal.

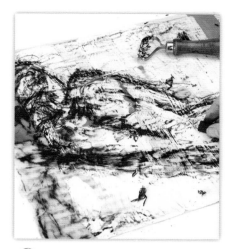 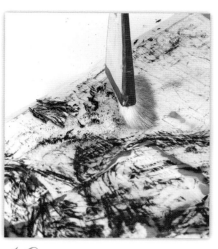 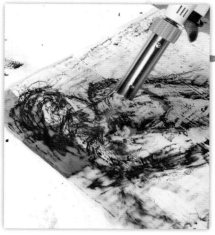

9 Continue to draw and scrape the image, shaping it with both the charcoal and loop. Rub some charcoal in open areas of the surface and scrape to give the overall effect of a dreamy work in progress.

10 Sweep away all the wax and charcoal shavings with a soft brush.

11 To fix the image permanently in the wax, fuse lightly over the entire surface, pull the flame away for a few seconds and then repeat over and over again until all of the charcoal has been absorbed by the wax and the image is set. Be more cautious than aggressive in this process and watch for the charcoal to turn a darker shade of black as the wax absorbs it.

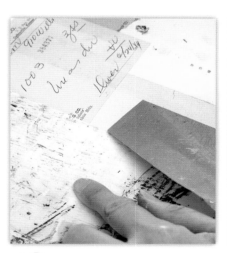 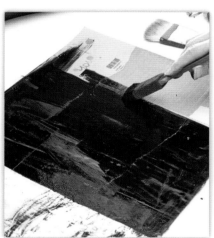

12 Remove the painter's tape from the center of the collage immediately while the wax is still warm.

13 Apply two coats of India ink with a disposable sponge brush to the right side of the collage. If you get any ink on the surface of the wax, wipe it right away with a baby wipe.

14 When the ink dries, prime the black surface by rubbing the side of a piece of chalk across the entire area.

15 Wipe it away with a clean dry rag or chalkboard eraser.

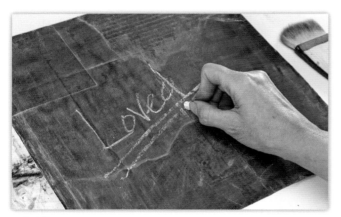

16 The surface can now be used as a chalkboard.

17 Mount the entire collage to a cradled panel with paste and weigh it down with the rice bag while drying.

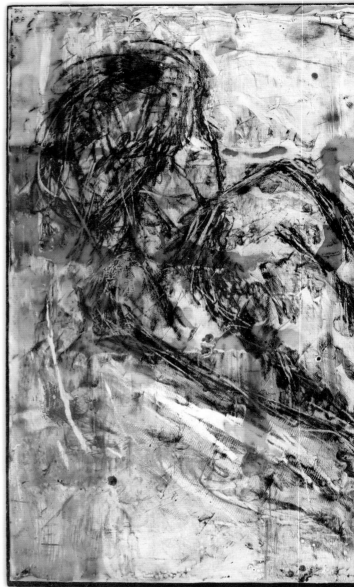

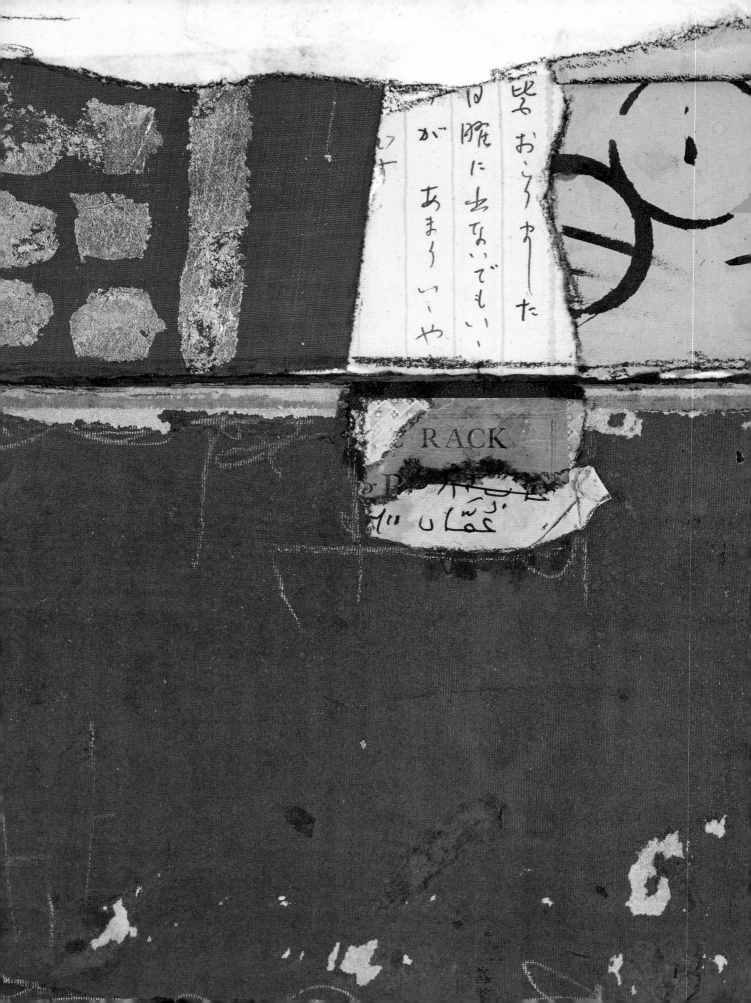

Inspiration

A Gallery of Art

To study music, we must learn the rules. To create music, we must forget them.

— NADIA BOULANGER

The contemplative way that I approach the canvas is similar to the way that I approach healing and growth in my life. An introvert by nature, I find moments of introspection to be revolutionary to the process of becoming the truest version of who I am, both in my studio and out of it. As I examine the bits and fragments of memory and bind them to the composition in the form of paper, scrap and glue, I am acknowledging myself in relation to the world around me. This journey as an artist was not a linear path that started with the decision to attend college and pursue the means to a career. Though art was my passion and desire when attending a university high school as a young teen, my focus shifted at the mere age of sixteen with the birth of my son. Not for another twenty years would I remember the desire I had buried within, so adept I was at playing the role of what I thought was required to be a "good" mom, wife and employee.

There is a sense that this "road of trials," as Joseph Campbell relates it, is one that was intended to create in me a tenacity that refuses to let go of the knowledge that I was an artist once I became aware of it. My journey was an important one to creating and revealing my true self, and not one moment could be changed without changing the artist-woman I am today. It is more than just pursuing a passion, more than just finding my calling. It is a matter of just being. I am who I am, and who I am includes every part of my journey—good, bad, shame-filled or carefree.

This awareness presents itself to me and I follow it each day. As it informs me in my work, the story is revealed in the pictures I create. Whether I have words to convey exactly what any given collage is about or not, it is under the umbrella of this theme. I have come to know it as my redemption.

I asked earlier in the book what you would discover your story to be. Here in this last section I am excited to present the work of a handful of artists whom I greatly admire. Whether they share with you a few words about what inspired their work or simply the artistic process behind the making of it, they are sharing an essential part of their own overarching theme. What has caught this artist's eye? What materials does she choose to work with and why? It is all a part of the intuitive process where each one was able to say, "I like this. I don't like that. I want to use this. What happens if I try that?"

Jan Avellana

The process for this piece started as it usually does, with a base layer of ephemera collaged onto a vintage book cover. I like working from this foundation—the process of selecting papers and gluing pieces down acts as a warm-up, and thoughts begin to flow. If I start with an initial sketch, the layout often changes significantly during this preliminary period as shapes and areas of interest emerge from the page.

For this piece, I began by adding swatches of color, using gesso liberally to block out other areas to let the eye rest.

The images and symbols appeared on the page intuitively; I had no preconceived plan in mind when I began. Soon I understood that the images visualized the idea that small pieces eventually become part of a larger whole. This message became an encouragement to keep going with my evolving body of work, one piece at a time. The writing on this piece was the last element added to this personal collage.

www.janavellana.com

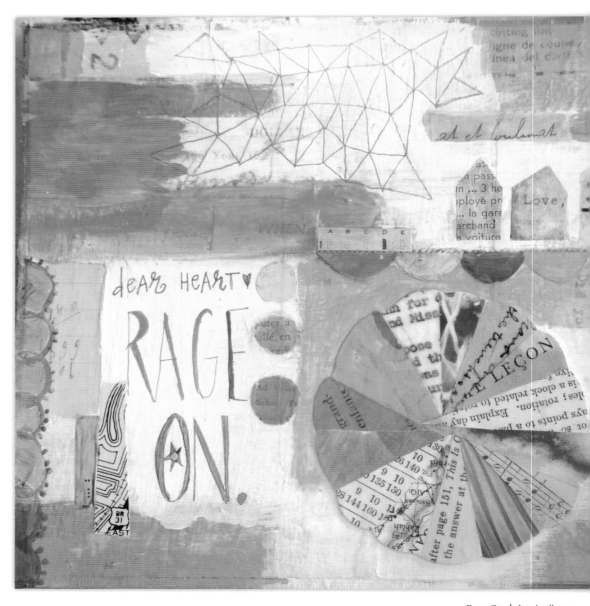

Rage On | Jan Avellana
Mixed media on vintage book cover

Elizabeth Bunsen

I am seduced by spaciousness—internal and external and how they dance together—echoing and mirroring each other.

I am curious about the secrets of leaves, the alchemy of tea and rust, the indelible blue dance of sky and water, the layers of past and present.

I collaborate with natural processes using a sensory vocabulary to create incantations and hymns of gratitude to the magical gift of BE-ing.

www.elizabethbunsen.typepad.com

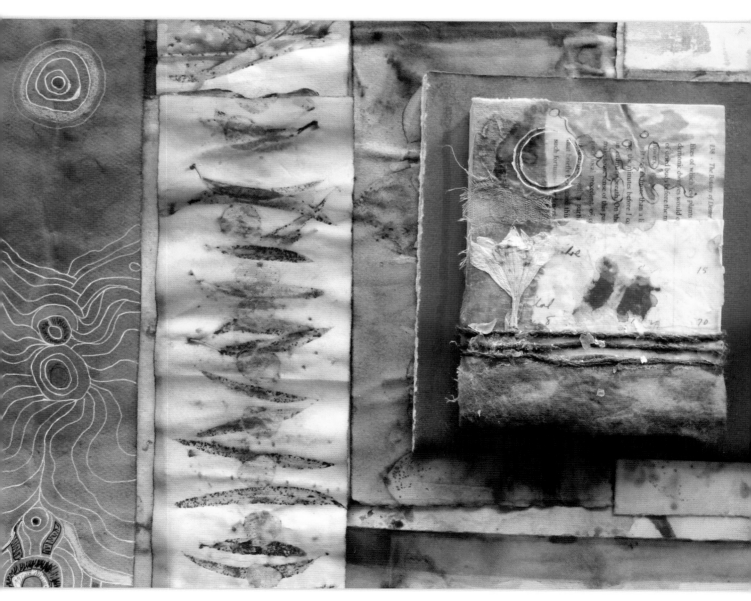

Untitled | Elizabeth Bunsen
Fabric, ephemera, mixed media

Kathryn Frund

My paintings and assemblages address the intimate and complex relationships between nature and humanity. The work explores the themes of stewardship and damage, fluidity and control. Through the layering of paint and the reconfiguration of material, the work seeks to open pathways and find restoration and balance. The paintings become a spiritual and material exploration into the nature of our presence in the physical world.

www.kathrynfrund.com

 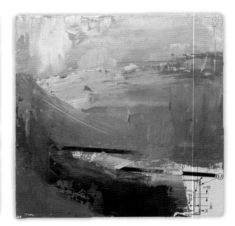

Schema, triptych | Kathryn Frund
Mixed media on panel

Laura Lein-Svencner

I like to challenge my abilities by setting limits with how many collage papers I use. In this case I've chosen one piece of paper that I've used to create a variety of colors and visual textures. The paper I started with was brown packing paper from a shipment of art supplies; applying some acrylic paints to the surface starts the process. Arrangement of the paper begins with contrast, working with the straight and torn jagged edges, much like our own lives: smooth and rough spots. I arrange the paper starting from an emotional state to self-express through a graphical abstract composition, working with size, color and value. Being aware that I have only this one piece of paper, I push myself to try something different,

like folding over the paper and exposing the back side to repeating a ladder effect in the background. Intuitively I listen and invite the black thread; at that moment the collage takes on a direction all its own. Simply adding the hand-pulled stitch and making a spontaneous choice to leave the thread hanging in some areas made me realize I had been thinking of those around me who struggle through life. Not realizing I had been carrying these thoughts. I asked myself *What is it that gets us through times like these where you are barely hanging by a thread?* And for me it's hope.

www.lauralein-svencner.com

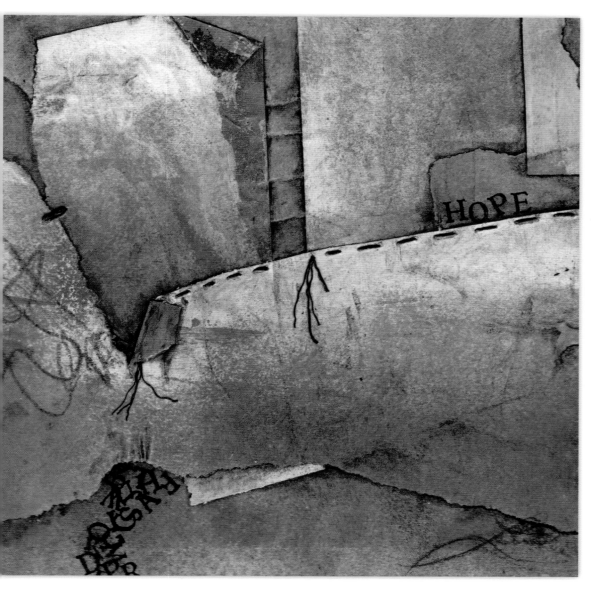

Hanging by a Thread
Laura Lein-Svencner
Paper, thread, acrylic, mixed media

Helen Lewis

As an artist and calligrapher, I am fascinated with words and text—both their meanings and their shapes and appearance, and I incorporate letters or words into much of my artwork. Sometimes, as is seen in this collage, it is only a snippet of handwriting from an old envelope or a bit of text from a vintage book that is included. Often, I use encaustic medium and technique with my collage, and I particularly love the luminous qualities and depth of layers that emerge as I fuse the various elements together.

John's Gospel describes the *Word* not merely as an element of speech but as a light shining in our darkness. I believe that light works in our lives on many levels, extending beyond the surface and constantly inviting us to go deeper, revealing more of His heart and more about ourselves as we do so. My art frequently reflects that process by hinting at layers and inviting the viewer deeper. Even the name of my artwork company, Illuminating Words, alludes to this through several layers of meaning.

www.helenlewisart.com

Contents | Helen Lewis
Ephemera, encaustic, oil, mixed media

Bridgette Guerzon Mills

After experiencing a powerful flood that filled my studio with three feet of water and destroyed many works on paper and canvas, as well as years of collected materials for my mixed-media artwork, I was left with the task of rebuilding my studio and creative practice. This mixed-media encaustic collage painting speaks to this rebuilding period. Two artist friends sent me paper from their own collections to help rebuild my lost materials and to help me get back on my creative feet. The paper used in this piece comes from those contributions, some of which were vintage sheets that came all the way from a flea market in Paris! The stained, age-worn papers speak to the passage of time by symbolizing the wear and tear of the elements on material things.

The writing on the paper emphasizes the idea of chronicling our stories, of the attempt to document life that is so impermanent. I pieced together torn bits of paper, much like the reconstructing of my life. There are also bits of paper that I rusted to emulate the rust of some of my metal materials in the wake of the flood.

I took the photo of the leaf and manipulated it using an application on my phone. When I added it to the piece, it looked like it had been exposed, similar to an X-ray; I thought about how difficult experiences often can expose our true nature. I added the copper sheeting that I saved when we tore down the old structure of what is now my new studio. I love the contrast of the soft, organic wax beside the hard metal. The patina on the copper reinforces the idea of the power of the natural elements on us all.

www.guerzonmills.com

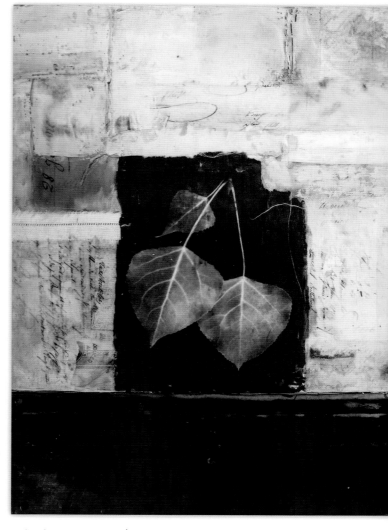

Light of Our Own Nature | Bridgette Guerzon Mills
Ephemera, encaustic, mixed media

Crystal Neubauer

This work so perfectly illustrates how collage has become a teacher to me. In the midst of one of the busiest seasons of my career, I had but one week to produce nearly an entire body of work for a show. Under this pressure, I had a hard time loosening up and began to produce work that I didn't feel satisfied with. I set this particular piece aside and declared it a wash as I left to set up my booth.

At the end of a long day, I returned home aching and tired, ready for bed, but instead, I found myself back in the studio sitting silently with this canvas in front of me. As my thoughts turned to the events of the day and the weekend ahead of me, I absentmindedly knocked certain areas back with white paint and highlighted others with pencil, not thinking about what I was doing or trying to force anything to happen.

When I finally sat back I was startled at the results. The work went from trash to a center-stage treasure, all because I had allowed myself the freedom to play. It is from this place of slowing down and letting go of control that I am most able to connect with my most authentic self. It is this place of unabashed freedom that I wish to approach life, both in and out of the studio.

www.crystalneubauer.com

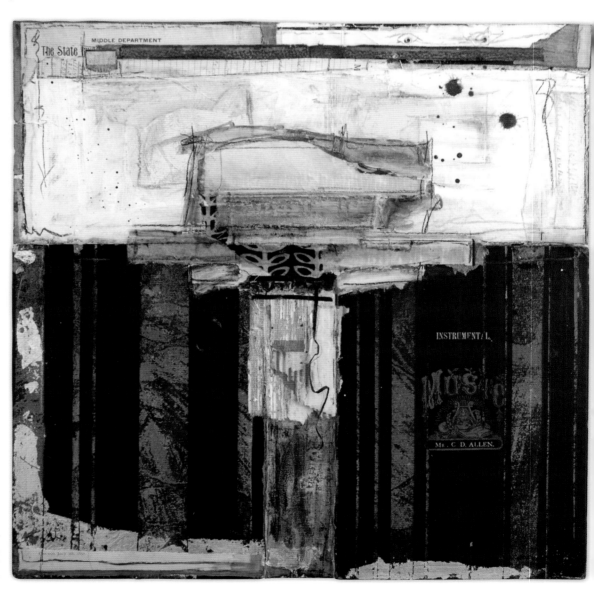

She Had Other Things on Her Mind
Crystal Neubauer
Collage, mixed media

Fran Skiles

I layer paint, crayons, charcoal, ink, Japanese and Chinese paper, found papers, photography and fabric onto canvas, paper and board. Making art using mixed media and collage has been a constant in my life. The process is intuitive, each step giving direction to the next.

I create an abstract landscape that captures nature's essence.

You are invited to interpret and respond to this work in any manner you feel.

www.franskiles.com

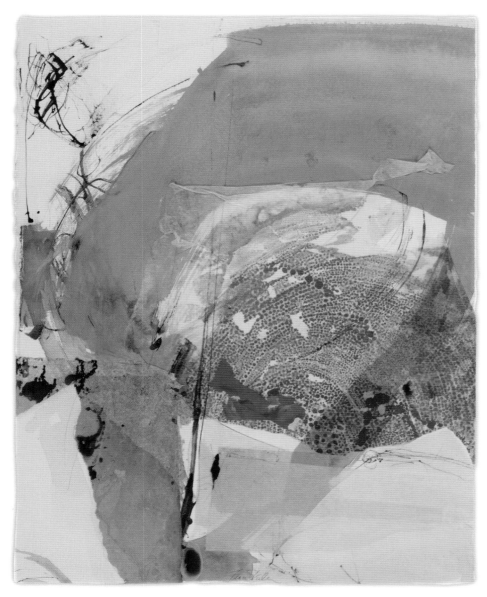

Bauxite | Fran Skiles
Collage, mixed media

Susan Stover

On a recent trip to Indonesia my love of the textiles of that part of the world was rekindled. I am interested in the value and importance that other cultures have in the making and use of their traditional fabrics, particularly in relation to their spiritual beliefs. I am attracted to their use in ritual and the spiritual meanings that are imbued into the making, coloring and patterning of the cloth. This connection between art and spirituality has always been at the source of my own art-making, and my goal is to create works that have this sense of transcendent mystery and purpose.

www.susanstover.com

Poleng | Susan Stover
Encaustic, silk, mixed media

Melinda Tidwell

My work often begins as a response to my materials, which are primarily vintage books. In this piece, a small paperback book about mammals got it all started. The section titles had a poetry about them I could not resist. I was also inspired by the triangular creases in a tattered paper book cover. Once these narrow strips were in place, a network of diagonals quickly grew out of them. I work to get a compelling balance of darks and lights in a long process of pasting over and tearing off. I seem to complicate and simplify in turns, until a harmony between activity and rest comes together.

www.melindatidwell.com

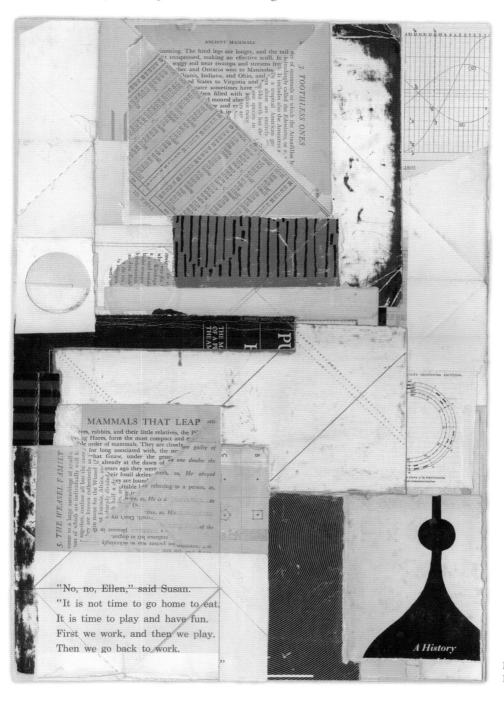

Mammals That Leap | Melinda Tidwell
Book parts, graphite, paper, mixed media

Index

About Crystal Neubauer

Regardless of the mediums I include, my work always comes down to collage. Whether rendered in a 3-dimensional assemblage fashion or a 2-D picture plane, my fascination begins with found papers. I see these items as a metaphor for our own lives and seek to bring them together in a way that opens the viewer to a deeper experience of an overarching theme of personal redemption, where every part of who you are is embraced and nurtured. I call my process intuitive, but it all boils down to learning to trust and open oneself to the voice inside, the one that can guide creative decisions and bring about a much richer work of art than what skilled technique alone can do.

From obtaining gallery representation, to writing this book, to teaching workshops nationwide and opening a studio in my own neighborhood, learning to tune in to the voice within has led me on a journey of learning "I can"; and I am delighted to share what I have learned in hopes that others will achieve an "I can" experience of their own.

www.crystalneubauer.com
www.otherpeoplesflowers.blogspot.com

Acknowledgments

Thank you to Jamie Birr and the Shipshawana Auction for supplying the auction images.

Thank you to Sandy at Rhubarb Reign for many of the flea-market images.

Thank you to Kathy and Klaudia for spending your time letting me take pictures of your beautiful hands getting creative in my studio.

Thank you to Christine Polomsky and Amy Jones for making me so comfortable during the photo shoot.

They say that to succeed at anything in life, you should surround yourself with people who are seeking the same things. Jan, Amanda and Trish, thank you for being in my tribe. You inspire me, motivate me and hold me accountable to following the path before me.

And to Tonia, my editor, who is also a part of my tribe, thank you for believing in me and for staying open to my desire to write a book until *I* was able to believe in me enough to do it.

Dedication

To my mom: I have the fondest childhood memories sitting at your side working on arts and crafts. Thank you for nurturing the creative seed in me. And for loving me all the way to the place I am today.

And to my family: to my husband, Larry; my son, Jason; and my daughters, Kristin and Andrea. And my steps, who are no less my own, Laura, Jake, Amanda and Jordan. Thank you for being real. And for allowing me to be also. I love every one of you and wouldn't trade a single moment of our journey together. It is all a part of who we are as individuals and as a family. It all matters and every moment has served you in becoming the men and women you are today. I am proud of you all and I love you with every fiber of my being.

And to God: You placed these creative desires in my heart and delight to bring them to fruition.

EDITED BY Tonia Jenny

INTERIOR DESIGNED BY Hannah Bailey

PRODUCTION COORDINATED BY Jennifer Bass

Other fine North Light Books are available from your favorite bookstore, art supply store or online supplier. Visit our website at fwmedia.com.

a content + ecommerce company

19 18 17 16 15 5 4 3 2 1

DISTRIBUTED IN CANADA BY FRASER DIRECT
100 Armstrong Avenue
Georgetown, ON, Canada L7G 5S4
Tel: (905) 877-4411

DISTRIBUTED IN THE U.K. AND EUROPE
BY F&W MEDIA INTERNATIONAL LTD
Brunel House, Forde Close, Newton Abbot, TQ12 4PU, UK
Tel: (+44) 1626 323200, Fax: (+44) 1626 323319
Email: enquiries@fwmedia.com

DISTRIBUTED IN AUSTRALIA BY CAPRICORN LINK
P.O. Box 704, S. Windsor NSW, 2756 Australia
Tel: (02) 4560-1600; Fax: (02) 4577 5288
Email: books@capricornlink.com.au

ISBN 13: 978-1-4403-3585-3

Metric Conversion Chart

TO CONVERT	TO	MULTIPLY BY
Inches	Centimeters	2.54
Centimeters	Inches	0.4
Feet	Centimeters	30.5
Centimeters	Feet	0.03
Yards	Meters	0.9
Meters	Yards	1.1

Ideas. Instruction. Inspiration.

Receive FREE downloadable bonus materials when you sign up for our free newsletter at artistsnetwork.com/Newsletter_Thanks.

Find the latest issues of *Acrylic Artist* on newsstands, or visit artistsnetwork.com.

These and other fine North Light products are available at your favorite art & craft retailer, bookstore or online supplier. Visit our websites at artistsnetwork.com and artistsnetwork.tv.

Follow North Light Books for the latest news, free wallpapers, free demos and chances to win FREE BOOKS!

Visit artistsnetwork.com and get Jen's North Light Picks!

Get free step-by-step demonstrations along with reviews of the latest books, videos and downloads from Jennifer Lepore, Senior Editor and Online Education Manager at North Light Books.

Get involved

Learn from the experts. Join the conversation on